T0268129

IMAGES
of America

AROUND SPRINGFIELD

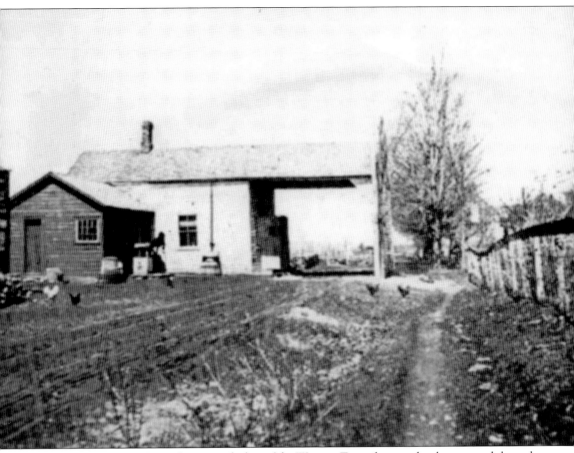

TURNPIKE TOLLGATE. Since the very early days of the Western Turnpike, travelers have moved through Springfield on what is now called US Route 20. This photograph of the tollgate shows the turnpike as a dirt road with chickens running about. The location is marked by a historical marker on the north side of the highway near Shadow Brook. (Courtesy of the Springfield Historical Society.)

ON THE COVER: HANNAH CONKLIN'S MILLINERY. Hannah Conklin sold various articles of clothing here as well as very fancy hats. The shop also provided dress-making services. Later, this building became the Hecox Shoe Store before being converted to an auto repair shop called Bill's Garage, which it is to this day. (Courtesy of the Springfield Historical Society.)

IMAGES
of America

AROUND SPRINGFIELD

Nancy Einreinhofer
and Suzanne Goodrich

ARCADIA
PUBLISHING

Published by Arcadia Publishing
Charleston, South Carolina

Printed in the United States of America

Library of Congress Control Number: 2023932950

For all general information, please contact Arcadia Publishing:
Telephone 843-853-2070
Fax 843-853-0044
E-mail sales@arcadiapublishing.com
For customer service and orders:
Toll-Free 1-888-313-2665

Visit us on the Internet at www.arcadiapublishing.com

In memory of Noel Dries and Jane Prior, town historians who taught us well

CONTENTS

ACKNOWLEDGMENTS

It took assistance from many people and organizations to make this book possible. A special thank you goes out to the following: Fred and Maureen Culbert, Barbara Chamberlain, Mary Ellen Calta, Regina Oakes, Megan Culbert, Tom Canis, and all members of the Springfield Historical Society; Bill Harmon and Holly Waterfield, State University of New York (SUNY) Biological Field Station; Scottie Baker and Susan O'Handley, Otsego Lake Association; Jennifer Griffiths, Fenimore Art Museum; and Greg Farmer, Otsego Land Trust. Thanks also goes to Larry Smith of Hyde Hall and David Smith for answering questions.

The historical society is thankful for the generosity of departed members of the community who donated their archives to the society, therefore creating an invaluable resource: Homer Fassett, Janice Maine, Noel Dries, Nancy Smith Druse, and Jane Prior, just to name a few. "The History of Springfield," created in 1935 by Kate Gray, was an invaluable resource.

Of special merit are three other members of the historical society: Bob Einreinhofer, Nancy's advisor and collaborator; Nora Crain, who was a critical part of the team helping to think through the visual elements of the project; and town historian Fred Culbert, who checked all the facts.

Unless otherwise noted, all images appear courtesy of the Springfield Historical Society, which will receive the authors' royalties.

INTRODUCTION

Springfield has a long and varied history dating back to the Revolutionary War. A frontier region in the 18th century situated on the Great Western Turnpike, Springfield witnessed the westward pioneer migration and served as a way-stop for travelers and people moving goods and animals along the turnpike. That turnpike, known as Route 20, today begins in Boston and ends on the West Coast in Oregon. In the beginning, it connected Albany with the territory west of Springfield and enabled a steady stream of pioneers and settlers to move west. It also allowed for the transport of animals and produce from this productive region to the restaurants and families of Albany.

Blessed with rich and fertile soil and plentiful water, Springfield has always been a successful farming community. Beginning in the difficult early days of the post–Revolutionary War period, through the high-profit times of hop production in the late 19th century, to the dominance of dairy farms in the last century, Springfield has remained primarily an agricultural community. In the early days, the forests were cleared to create land for farming and because the wood was needed to build houses and barns; sawmills could be found near every stream.

In the 19th century, Springfield became a destination for vacationers. People seeking to escape the hot and polluted cities found Otsego Lake and the healing springs of Richfield and Sharon Springs a welcoming haven. Access to the region was made possible first by train transport and stagecoach and later by the newly invented automobile, which pushed the development of better roads and, eventually, a highway system.

Springfield's Gilded Age witnessed the development of six great estates on the northern end of the lake shores and other grand houses in and around Cooperstown. The wealthy proprietors, often "gentlemen farmers," contributed, perhaps inadvertently, to the preservation of the land and water. They also contributed to the building of important social networks such as the congregation at St. Mary's Episcopal Church and the now-defunct village Club House. Some old recreational institutions such as the Otsego Golf Course remain popular, while cultural organizations, prime among them the Glimmerglass Festival, have developed and continue to thrive.

The 20th century brought new challenges to the small family farm. As the cost of farm equipment increased and it became more difficult for the small farmer to compete, the next generation looked for employment elsewhere and the small farm was in jeopardy of disappearing. The Amish began settling in Springfield about 25 years ago. The Springfield community welcomes the continuation of farming traditions, which also help to preserve the area's land and water.

Today's varied farming includes orchards and fields planted with corn, wheat, and soy and provides a stable future for the town. The animals raised include the dairy cows traditional to Springfield as well as sheep, goats, and chickens. Artisan goat and sheep cheeses and organic farm-to-table produce are two examples of recent popular innovations.

There are organizations dedicated to the preservation of the region that have had a huge impact on Springfield and the surrounding area. The State University of New York has maintained a Biological Field Station on Lake Otsego since the middle of the last century. The research conducted there

includes the lake and the surrounding environment of forests, wetlands, and farmlands. Various organizations and scientists developed the Watershed Management Plan in 1998. The plan was updated in 2007 by the Otsego County Water Quality Coordinating Committee. Implementing the plan with ongoing monitoring is key to the natural preservation of the region. Conservation is an ongoing process and requires dedication and vigilance on the part of all who chose to be advocates.

Susan Fenimore Cooper, in her 1850 book *Rural Hours*, writes beautifully and lovingly about Otsego Lake and the surrounding countryside. She writes of a land recently inhabited by indigenous peoples and recently developed by her own ancestors. Her observations describe the land, the lake, the rivers, and the changing weather conditions. She records agricultural practices and the human impact on plant and animal life, sadly recording the loss or reduction in the number of certain plants, birds, fish, and animals. She muses on the balance between the natural world and the human development of that world: "This general fertility, this blending of the fields of man and his tillage with the woods, the great husbandry of Providence, gives a fine character to the country . . . which it must lose if ever cupidity, and the haste to grow rich shall destroy the forest entirely and leave these hills to posterity, bald and bare, as those of many older lands. No perfection of tillage, no luxuriance of produce can make up to a country for the loss of its forests."

While the twists and turns of history and development have transformed the Springfield landscape again and again through the centuries, Susan Fenimore Cooper would have no problem recognizing this place. The region has maintained its bucolic charm and the natural beauty of its rolling hills and treasured Glimmerglass are essentially unchanged.

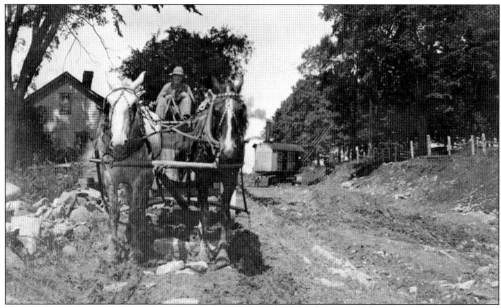

BUILDING ROUTE 20. Route 20, originally a toll road and now a cross-continental highway, began as the Great Western Turnpike and connected Springfield and points west with the City of Albany. The state took over maintenance of the route in the early 1900s. It was named Route 20 in 1926 and was one of the most traveled roads until the thruway was created in the 1950s.

One

Early Farming
in Springfield

One of the first major industries in the Town of Springfield and surrounding communities was farming. The land in Springfield is classified as "Honeoye Loam," among the most fertile soils. The big field crops were hay and corn used as feed for livestock. Other crops included wheat, apples, potatoes, and hops.

In the 19th century, Springfield was a major hop-growing region, hops being a key ingredient in brewing beer. Hop farms dominated the landscape on either side of what is now Route 20 and extended south along the shores of Otsego Lake. By 1840, New York led the country in hop production, and by 1860, ninety percent of all hops were grown in New York. The "Blue Mold Blight" of 1913 was the beginning of the end of the hops culture in Springfield and New York State. Hop production is currently returning to the area with some private farms planting the crop and the regional breweries growing their own.

The livestock raised on Springfield farms included beef cattle, sheep, oxen, pigs, and perhaps the most important, milking cows. After the Revolutionary War, this part of New York State became a great cheese-making region, supplying cheese to the cities of Albany and New York and the pioneers heading west on the Great Western Turnpike. After 1920, due to the loss of the hops industry and improved technology in cooling and shipping milk, dairy farming increased. The milk from farms now became a commodity on the market. It was shipped by rail as far away as New York City.

Creameries, where milk and cream could be processed safely and where butter and cheese were produced, grew in number. Milk was shipped from the farms in metal cans. Early on, the milk was kept cool with ice harvested by the farms. By the 1940s, milk coolers running on electric power became available. By the 1950s, bulk tanks came into use, which kept the milk cooled until tankers collected it. The Springfield area and Otsego County still boast a number of dairy farms, and artisan cheese is made here.

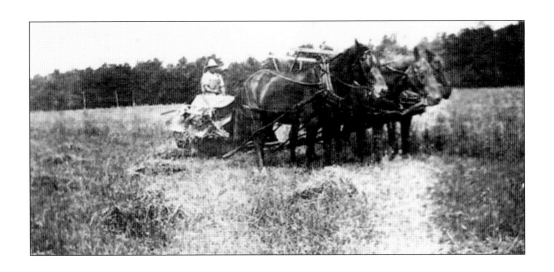

HARVESTING CORN. By the late 19th century, the corn binder had been introduced. This allowed farmers to harvest corn without having to cut the stalks by hand. The corn was cut and bound with twine into bundles and then pitched onto horse-drawn wagons. This corn binder was pulled by a team of three horses. Corn seeds were usually planted by hand in tilled earth.

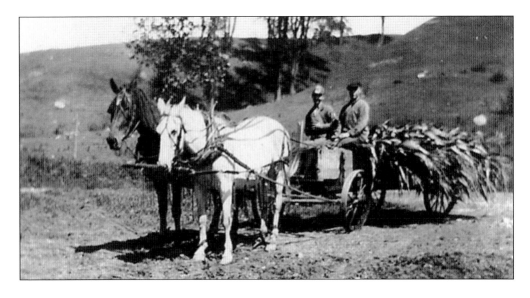

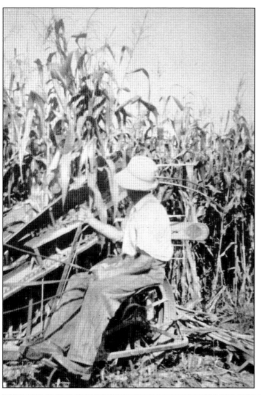

MAN HARVESTING CORN. If the corn was to be used for food for pigs and chickens, the corn was dried, and the ears were broken off by hand. A social event called a "husking bee" was held, where the ears were husked and fed into hand-cranked shredders. By the 1940s, corn pickers pulled by tractors picked and husked the corn, leaving the stalks behind.

FASSETT FARM. This farm is known as the "Clinton Camp Farm" because Gen. James Clinton made his camp near here during the Revolutionary War in the Clinton-Sullivan Campaign. The original farmhouse was built by William Hardy II in 1831 and is the present home of Kermit and Irene Fassett.

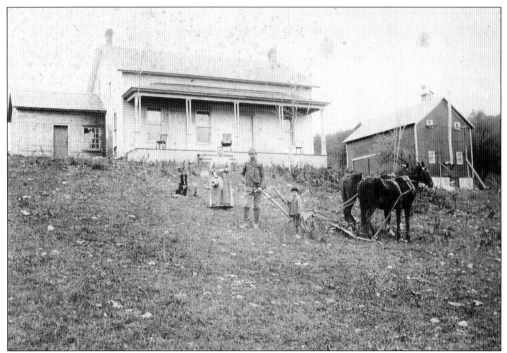

THAYER FARM. The little boy in this c. 1880 photograph is Grover Thayer. He stands on the Thayer Farm with his mother and his father, who is poised to use the horse-drawn plow. Grover would grow up to marry Martha Whipple and have two sons: Willie and Rufus. Thayer's farm grew to stretch from the shores of Otsego Lake up the mountain to Rum Hill.

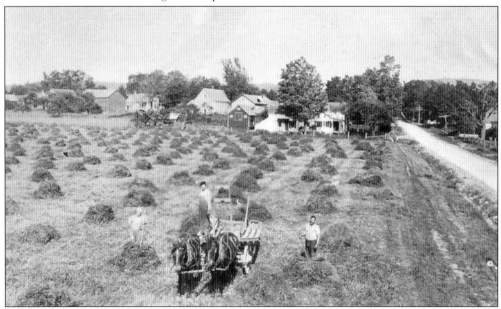

HAYING, 1922. Making hay has been a standard agricultural chore throughout history. Hay was cut and piled into haystacks. Horse-drawn wagons transported the hay to the barn where it might be baled. Bales were manually made before automatic balers came into use. The hay was piled and pressed into boxes and then wrapped with wire.

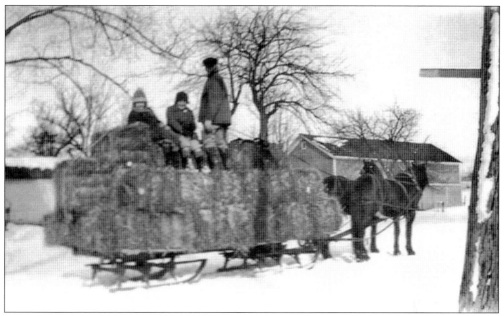

HAYRIDE IN WINTER. A horse-drawn sleigh piled high with hay bales made for a fun winter hayride. The sound of sleigh bells and the whisper of the runners through the snow were said to be a winter delight. Passengers would bring heated bricks to help keep themselves warm.

ARTHUR STOCKING FARM. Stocking family members were among the earliest residents of Springfield. This farm, located north of the intersection of Routes 80 and 20, was near Hayden Creek. The creek was dammed at the time of this photograph of a family gathering, creating a pond.

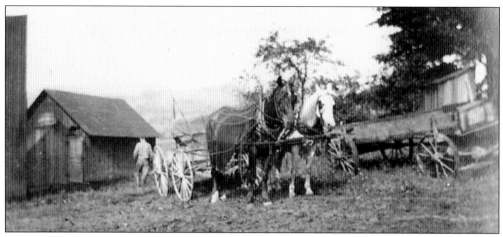

HORSES AND WAGONS. Horse-drawn wagons and carriages were both a means of transportation and essential tools for a working farm in the 19th century. This farmer has both a carriage, mainly used for transportation, and a rugged, simply constructed work wagon for farm chores and moving supplies.

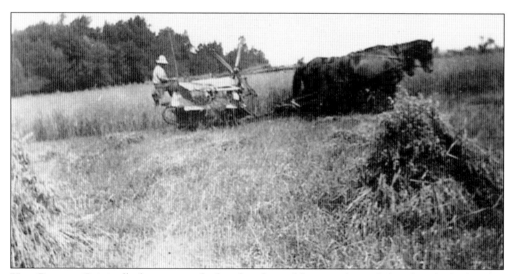

HAY CUTTER. Originally, hay was cut by hand with a sickle or scythe and then hand-raked with a wooden rake. Later, as shown here, horse-drawn mowers were used. The hay was left to dry in the field and then gathered loose into wagons to be pressed into bales.

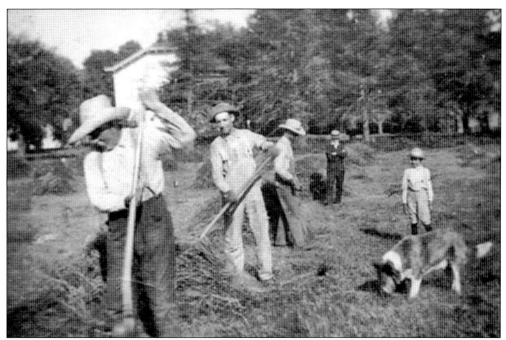

MEN RAKING HAY. According to the reminiscences of farmer Homer Fassett, "The Second World War made it difficult to obtain machinery. Before the war, milking, manure spreading, and other chores were all done by hand. Without new machinery, farmers kept to the old ways."

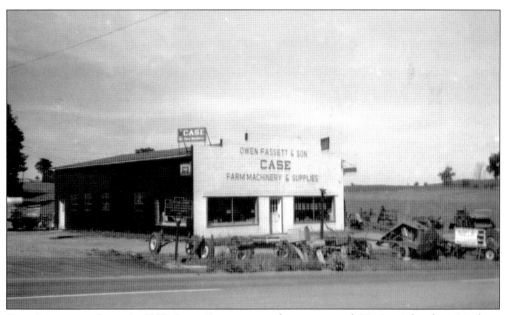

CASE GARAGE AND SALES. In 1932, Owen Fassett received a contract with J.I. Case Threshing Machine Company. Parts were shipped to Owen and his team and assembled and stored in a barn. Some of the items assembled were plows, harrows, corn planters, and grain binders. The machinery shop was built during the war. The building still stands on the corner of US Route 20 and Fassett Road.

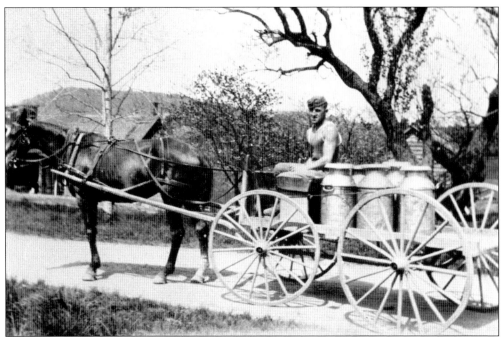

MILK CANS. The milk cans were loaded on the cart for delivery to the creamery, where the milk was made into butter and cheese. The cans would be cleaned and returned to the farm to be filled with milk again. Milk cans were used on some farms as late as the 1960s, which is when large refrigerated tanker trucks came into general use.

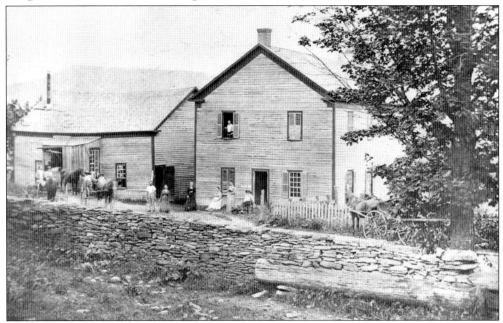

GRAYVILLE CHEESE FACTORY. Small cheese factories were being established in New York after 1850. Cheese factories were an excellent way to preserve milk by turning it into cheese. With the US population growing dramatically, cheese was in great demand both locally and by pioneers and settlers heading west.

DUTCH CORNERS CHEESE FACTORY AND ROCKDALE CREAMERY. The milk was delivered to the creamery in large cans. Note the wagons lined up at the Rockdale Creamery. The cream, which would float to the top, would be separated from the milk. The typical cheese producer would skim off the cream from the milk to use for making butter and then use the rest of the milk for cheese. The milk would be curdled, and the whey was removed and salted. The curds were cut into smaller pieces and heated to release more whey, which was drained off. The remaining curds were pressed into molds and left to age. Dairy farmers said turning milk into cheese was like turning lead into gold.

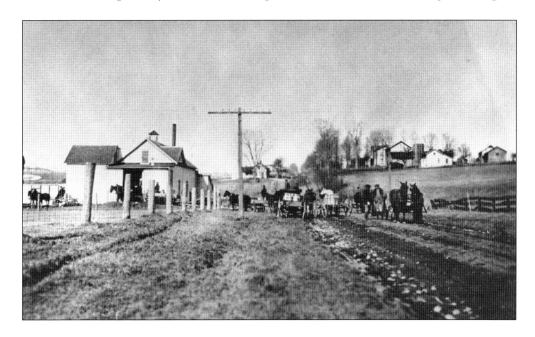

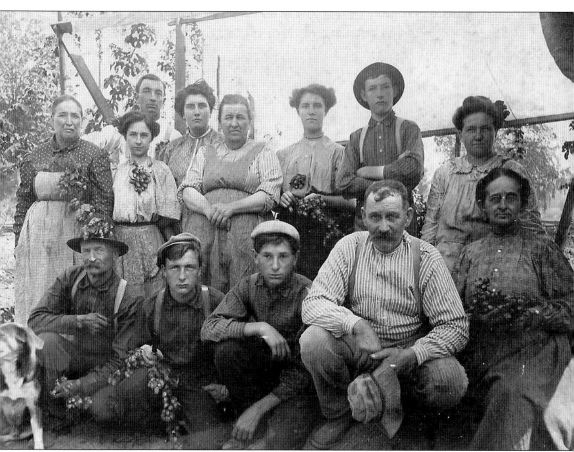

EARL HOKE HOP FARM. Frederick Hoke was one of the first settlers in the land that would become Springfield. He purchased land on the west shore of Otsego Lake, and according to Kate Gray, many generations made that land their home. Earl Hoke was the fifth generation, and he operated a successful hop farm. As early as 1808, hops were established as a commercial crop in Springfield and the surrounding region. It would continue as a dominant, very profitable crop through the turn of the century. The hop harvest took place in a two-to-three-week period in late August or early September. During this small window of time, families worked together, and workers came from Albany and other cities to assist with the harvest. The hops harvest was considered a social event—a chance to see old friends and meet new people.

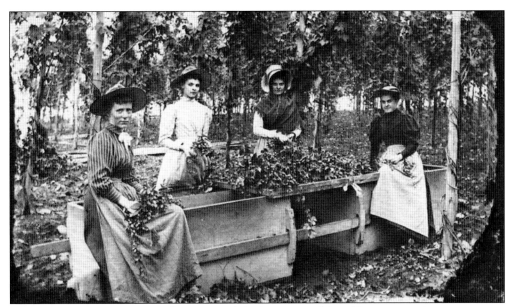

HOP PICKERS AND HOP BOX. Pickers stripped the hop vines of their blossoms one by one, grasping the sticky, pungent bloom and stuffing it into a sack. Note the gloves worn by pickers to protect their hands. Large, brimmed hats provided protection from the sun.

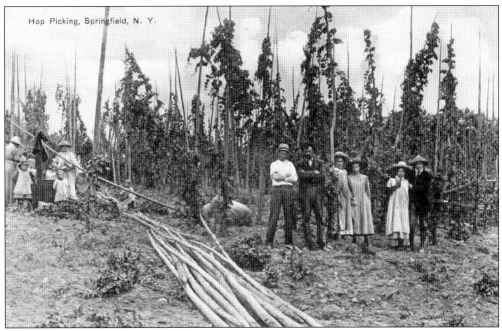

Hop Picking, Springfield, N. Y.

HARVESTING HOPS. The men cut the vines at the bottom and pulled the pole from the ground. Then the hops were placed across a long rectangular box, where the women would pick off the blossoms. The blossoms were then transferred to the hop house. This photograph was taken at the Edith Hinds Farm near the Puckertown School.

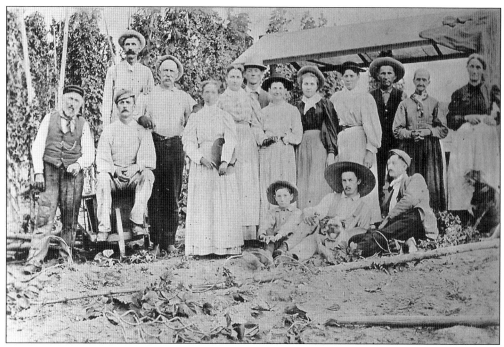

RINGWOOD FARMS, 1897. Many of Springfield's farm families grew hops, including the Alf Cary family, pictured here at Ringwood Farms. Among the other family names on record are Hoke, Young, Gray, Smith, Clarke, and Bartlett. The soil and climate in Springfield were conducive, and once the plants were established, they required little attention.

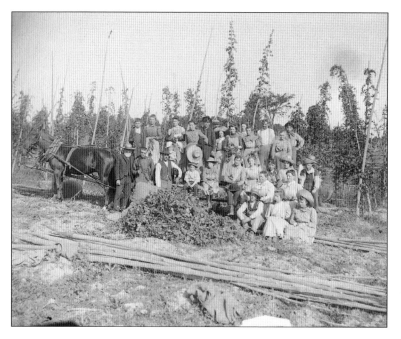

PILING THE HOPS BEFORE TRANSFER. The hop blossoms are piled high, having been picked by hand from the vines. The rows of vines were spaced to allow for cultivation. The hops will now be transferred to the horse-drawn wagon and taken to the hops barn to be processed.

Two Couples at Work. Young women and men were hired as pickers and box tenders, as well as to work in the hop houses. They looked forward to the hop-harvesting season and time spent working together. Often, the evenings were spent at informal dinners and dances where they could socialize.

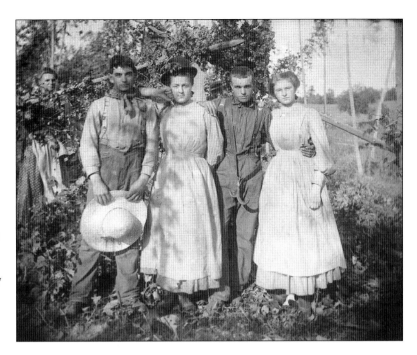

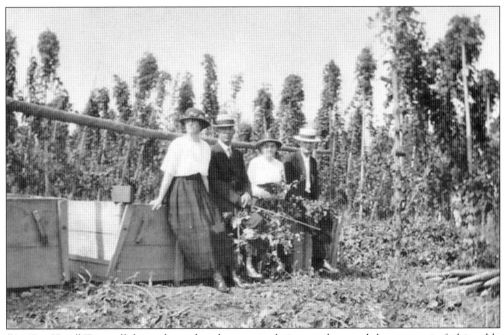

"At The Hop." Two well-dressed couples, the men in their straw hats and the women in fashionable dresses, illustrate how the hop-picking season was a social event for some, offering a chance to make a romantic match. Workers looked forward to being "at the hop" and mingling with other young people.

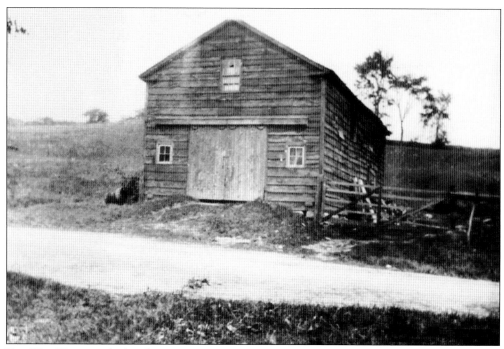

Two Hop Houses. The hop house was a common feature of the Springfield landscape throughout the 19th century, and some hop houses remain. The Craig Lynn Hop House (below) is located on Route 31 South. The blossoms were placed on the upper-story slatted floor on cheesecloth. A wood stove on the first floor provided the heat to dry the hops. The next day, the blossoms were moved to the adjacent room to cool and then pushed through a hole in the floor to the hop press on the first floor. Bales of hops were similar to bales of hay.

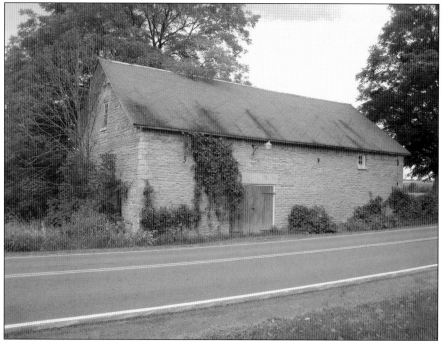

Two

Schools, Libraries, and Churches

The American pioneers first built their homes and then they built their schools, libraries, and churches. At the end of the 18th century, Springfield was the western frontier. The first church congregation assembled in 1787, and the first mention of a school was in 1797.

The oldest church building in Springfield was a Baptist church constructed in 1800. It counted 99 members at that time. Churches of several denominations followed, including two Episcopal churches and a Catholic, a Presbyterian, a Methodist, and a Universalist church. Church buildings in the early days also served as general meetinghouses in addition to places of worship.

Early schools in Springfield were rough one-room buildings heated with wood stoves. Members of the state legislature from Otsego County met in 1811 to propose a system for the establishment of common schools. The Town of Springfield was divided into nine districts and so numbered. As the population expanded rapidly, the districts grew in number. As group transportation of students became available, the one-room schoolhouses consolidated into "union" schools. Eventually, between changes in the student population numbers, modes of transportation, and educational philosophy, unionization of the schools became the way forward. Today, there is one school serving the student populations of Springfield and Cherry Valley from pre-K through 12th grade.

In the early 20th century, Springfield had two libraries: the Catlin Memorial Library and the General James Clinton Library. The Catlin Library roots were founded first in 1894 as a group of residents met in private homes around town. The library moved to the Kit Shipman Catlin Memorial Chapel following the disbandment of that congregation in 1921. The General James Clinton Library was formed in 1909. The idea for the library originated with the local chapter of the Daughters of the American Revolution (DAR). The DAR raised the initial funds for the library, which were matched by the state. State requirements for libraries in the 1990s triggered the consolidation of the two libraries in a central location. Today, the Springfield Library is conveniently located in the Springfield Community Center.

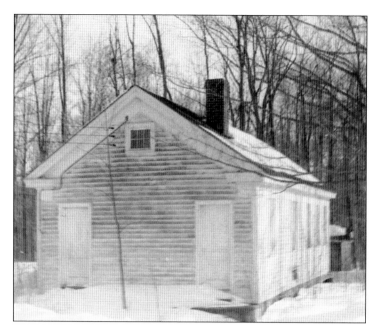

CONTINENTAL SCHOOL. The first school in Springfield, the Continental School, began as a log structure and was replaced by a framed structure in 1800. In 1859, a new school was built nearby on Dean Rathbun Road. In 1939, the Continental School centralized with Springfield, and the school was closed. In 1981, the Town of Springfield auctioned the building and land. It was purchased by Myron and Kermit Fassett for $5,000.

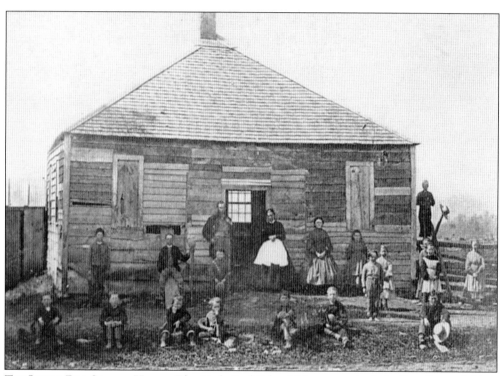

THE LITTLE RED SCHOOL HOUSE. The Little Red School House was built in East Springfield in 1800. George Little was the instructor. It was referred to as the "schoolhouse that stood in the road" because when the Turnpike was constructed, it came very close to the school's front door. Kate Gray records that the children delighted in throwing stones at the droves of sheep and cattle that passed by.

PUMPKIN HOOK
SCHOOL—OLD
STONE SCHOOL.
According to Janice
Maine, the first
building stood
near Pumpkin
Hook Cemetery
on Pumpkin Hook
Road in the early
1800s. The new
schoolhouse,
known as the Old
Stone Schoolhouse,
was built on
Springfield Wagon
Road off Route 80
in 1830. The school
closed in 1930.

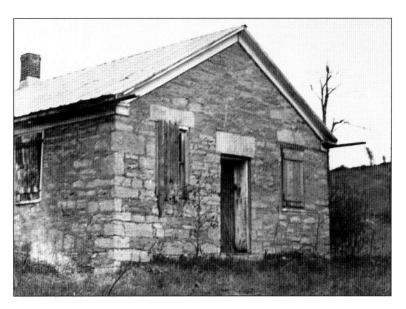

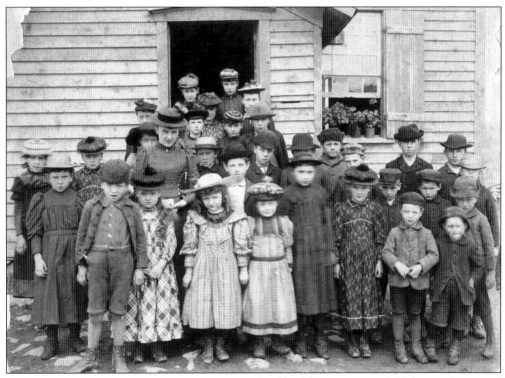

PUCKERTOWN SCHOOLCHILDREN, 1891 OR 1892. School buildings in Springfield during this period were very basic, one-room wood structures with wooden floors and simple benches for the students, and a slate board for students to share. Instruction included the basics—reading, writing, and arithmetic—and perhaps some history and geography. These children were part of a spirited group—everyone has a wonderful hat.

SALT SPRINGVILLE SCHOOL. The first log schoolhouse was built in 1827. The first frame schoolhouse was built in 1842 and had two rooms and, later, two teachers. High school students were sent to East Springfield in about 1935. In 1951, the district consolidated with Springfield but the elementary schoolchildren continued to attend this school until 1959. The building was sold in 1990.

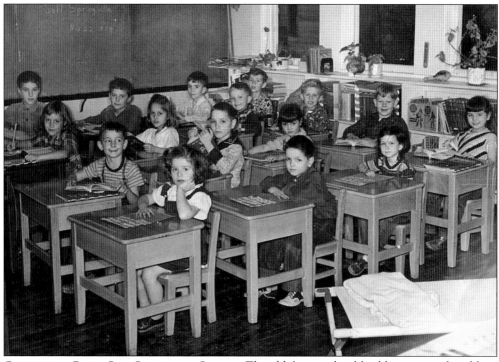

CHILDREN IN CLASS, SALT SPRINGVILLE SCHOOL. The old frame school building was replaced by a new school building at the time this photograph was taken in 1954. Sixteen children are sitting at wooden desks with wooden chairs with books and papers at hand. Chalk blackboards line the walls, and bookcases occupy the rear of the classroom.

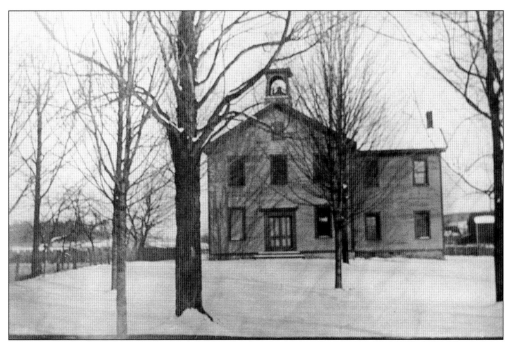

EAST SPRINGFIELD ACADEMY. In 1864, a seminary was built and used as such for six years. In 1880, East Springfield Academy was established under the charge of the state; a charter was granted, and a library was installed, with both supported by state funds and gifts. Students came from Springfield Center, Warren, Van Hornesville, Middlefield, Cherry Valley, Jordanville, and Sharon.

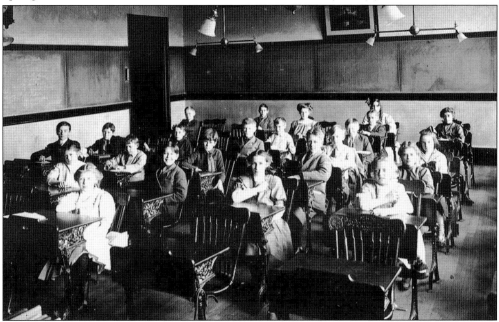

TURN-OF-THE-CENTURY ELEMENTARY CLASS. The children are pictured sitting in cast-iron desks with wooden desktops and inkwells. This room was state-of-the-art for the period, a long way from the rural one-room wood structure of the past. The ceiling lights were adjustable, a modern innovation. Note the slate chalkboard that contains a spelling list of 20 words.

EARLY CANVAS-TOPPED BUS and EAST SPRINGFIELD CENTRAL SCHOOL BUS. Group transportation for schoolchildren allowed students to move from the one-room schoolhouse, to which they had to walk, to union schools that could serve a larger population and provide more resources. The early school bus, which was a basic flatbed truck with benches inside and a canvas roof, was privately operated by Nate Southworth. Later, the town had its own school buses, which could carry more children. Joe Peaslee was the bus driver for the East Springfield Central School in 1930.

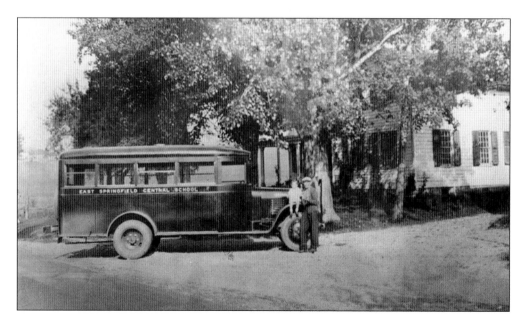

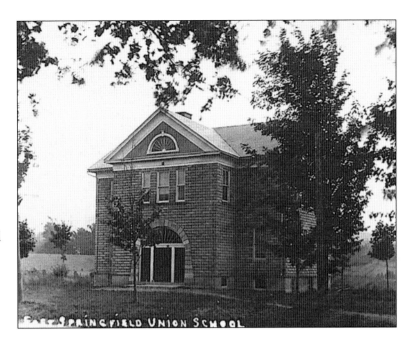

THE UNION SCHOOL. The first Union School on Route 20 was built in 1880. In 1902, the building was sold and moved, and a new schoolhouse was constructed in 1909. The school was centralized in 1939. In 1989, the Cherry Valley–Springfield Central School opened, and the old school was sold.

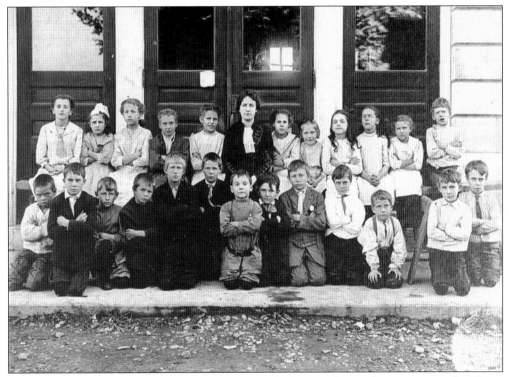

STUDENTS AT THE UNION SCHOOL. Students pose with their teacher at the entrance to the Union School on Route 20 in East Springfield in 1913. The students were instructed not to move but to fold their arms and stay perfectly still. Great discipline was necessary with the cameras of the day, which required long exposure times. Fidgety students would result in a blurred image.

SPRINGFIELD CENTER UNION SCHOOL. Located behind Harmony Row, this Springfield Center school was constructed in 1914. With an elegant design of simple lines, the wood-constructed schoolhouse was topped by a bell tower. Note the tall windows capped by a simple pointed cornice. The building was auctioned, relocated, and turned into a private home.

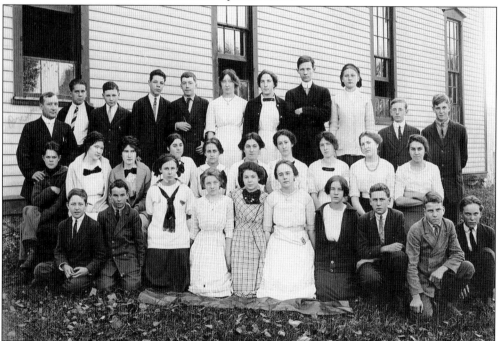

GROUP PHOTOGRAPH. Sophomore students of the Springfield Center Union School in 1914 gathered in front of the school building dressed in the fashions of the time, with boys in their jackets and ties. The girls' hair was parted in the middle and pinned up, sometimes braided.

OLD AND NEW SPRINGFIELD ELEMENTARY SCHOOLS. Classes remained in session in the 1923 school until the new one, under construction next door, was ready. The new building was designed by architect Myron A. Jordan of Richfield Springs. In classic International style, the building has rectilinear forms, large windows, and a flat roof and is devoid of ornamentation. It was listed in the National Register of Historic Places in 2011 and today serves as the town's community center.

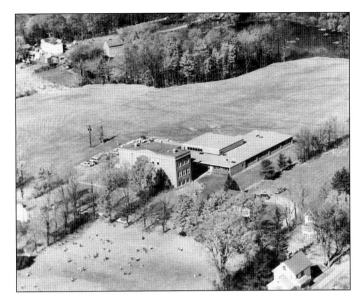

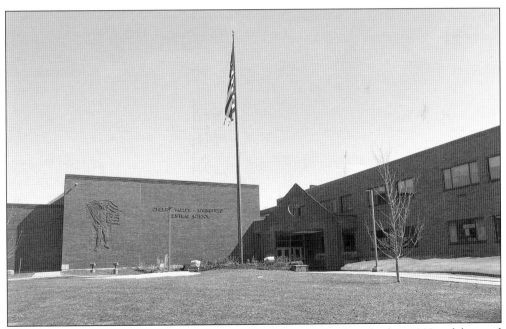

CHERRY VALLEY—SPRINGFIELD CENTRAL SCHOOL. The Central School was built in 1989 and designed to provide the very best education possible by combining the resources of the two districts and establishing a school for children from Kindergarten through their senior year of secondary school. The facilities, in addition to the classrooms and laboratories, include libraries, a media center, and various athletic fields. Learning is personalized via mobile internet-capable devices.

SPRINGFIELD LIBRARIES. The Catlin Universalist Church, built in 1899, was used as a library beginning in 1920. The architecture was influenced by the Queen Anne style, and the pointed arch windows are a Gothic influence. It is now a private residence. In contrast, the Clinton Library was a simple brownstone structure. Located on Route 31 in East Springfield, the Clinton Library was originally formed with the help of the local DAR in 1909. The library was named after the Revolutionary War general James Clinton. The current Springfield Library was formed in 1999 by the merger of the Catlin and the Clinton. The old libraries were not able to meet the standards set forth by the State of New York, so the boards of both libraries agreed to merge into one facility to be located in the Springfield Community Center.

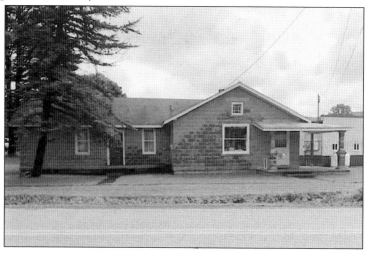

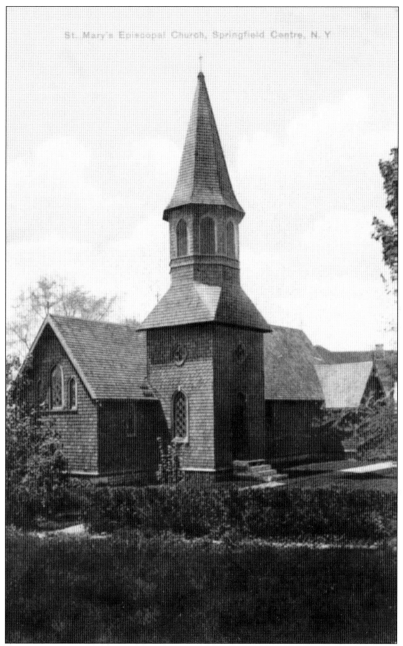

ST. MARY'S EPISCOPAL CHURCH. St. Mary's Episcopal Church, Springfield Center, was originally built in 1890 on Public Landing Road, where the Catholic church now stands. In 1899, Leslie Pell Clarke and Henry L. Wardwell executed the incorporation of the church. In 1900, the Wardens and Vestry of the Church purchased from Edward N. Catlin the property known as the Shipman Farm fronting what is now Route 80. The Shipman farmhouse was moved about 100 feet west. In 1902, the church building was moved to its present site (about a quarter-mile north). The cost of the property and moving of the building and all the required improvements were the gifts of Leslie and Anna Pell Clarke. In 1903, a new rectory was presented as a gift from Leslie Pell Clarke in memory of his mother, Anna Pell.

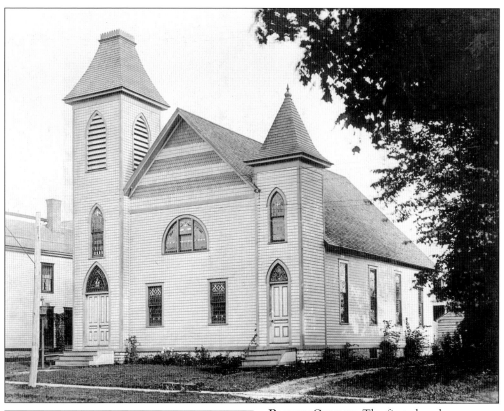

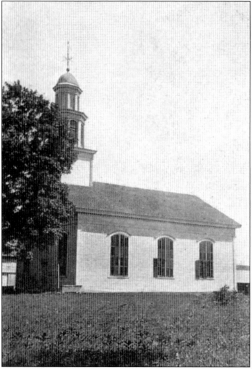

Baptist Church. The first church established in Springfield was a Baptist congregation in 1787. First located in West Village, the church counted 99 members by 1832. In 1855, a new meeting house was built in Springfield Center. This church burned in 1891, and a new (present) building was dedicated the same year.

First Presbyterian Church, Route 20. A Presbyterian congregation held services in the Baptist Meeting House in 1796. In 1809, the congregation completed the construction of its own church. The first Sunday school in Springfield took place in 1819. In 1857, the old church was taken down, and a new one was built.

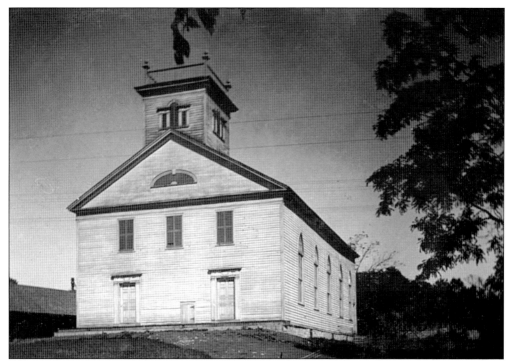

METHODIST CHURCH, ROUTE 20. In 1833, a meeting was held in the Little Red School House to plan for the building of a church to be called the First Methodist Episcopal Church of Springfield. The church was in operation until 1920 when it disbanded, and the property was purchased by the town in order to build the town garage.

UNIVERSALIST CHURCH, SPRINGFIELD CENTER. The first church building was erected in 1857. The building was destroyed by fire in 1899 and replaced by the Kitt Shipman Catlin Memorial Chapel, erected by E.N. Catlin in memory of his wife. This building was later converted into a library and is now a private residence.

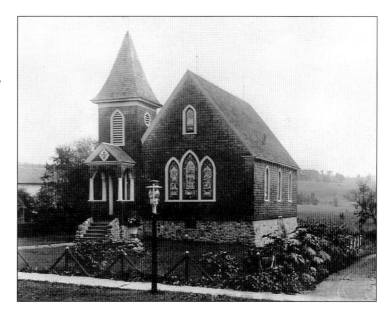

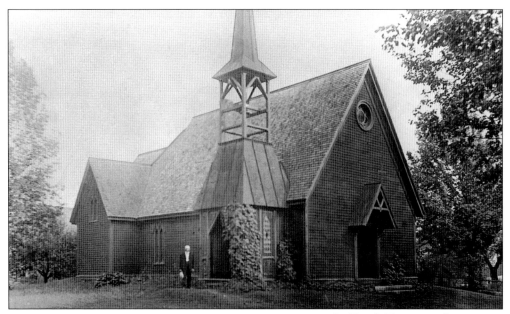

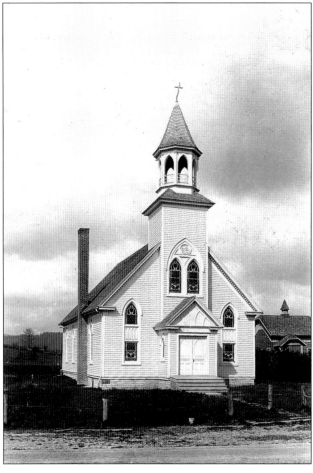

ST. PAUL'S EPISCOPAL CHURCH. The church was organized in 1871 in East Springfield, and the building was erected in the summer of 1874 on Route 31 south of Route 20. The first services were held in the spring of 1875. The rectory building is extant and is now used as a private residence.

CATHOLIC CHURCH OF THE BLESSED SACRAMENT, PUBLIC LANDING ROAD. The parish was organized as a satellite of Our Lady of the Lake, Cooperstown, in 1890. The church was built on Public Landing Road in 1903, and the architectural style is called Village Gothic. The lot and foundations were donated by Mr. Pell Clarke after St. Mary's Church was moved from this site. It is now a private home.

Three

SPRINGFIELD'S GILDED AGE

The rapid expansion of industrialization created great wealth in the late 19th century, while the expansion of railroads allowed for travel from the cities to summer retreats. Otsego Lake was a main attraction for both its beauty and the leisure activities it allowed. Wealthy families built summer retreats on acres of land at the northern end of the lakeshore.

Leslie Pell Clarke inherited a large swath of land that included the country estate called Swanswick. He sold about 300 acres to the east of Swanswick to his school friend, Henry Lansing Wardwell, a Wall Street commodities trader, who would build the great stone mansion called Pinehurst in 1888. Clarke sold land to the west of Swanswick to another friend, Arthur Ryerson, of the Chicago iron and steel company, J.T. Ryerson and Co. The Ryersons built their summer mansion called Ringwood Manor in 1901.

Cary Mede, originally a castle-style home designed and built by Harriet Slayton on the farm that she inherited from her uncle in 1889, has been through many alterations through the years. Various additions have enlarged the home, windows have been changed and porches added. The current owners, the Goodyear family, purchased the estate in 1920 and are responsible for many of the improvements.

Samuel Strong Spaulding of Buffalo purchased land just south of Cary Mede from Leslie Pell Clarke in 1901. Mohican Manor, Spaulding's vast, elaborate Federal-style mansion with beautifully designed gardens, stables, and boathouses, was one of the largest on Otsego Lake.

Hyde Hall, the sixth of the great estates at the northern end of Otsego Lake, was built by George Clarke between 1817 and 1834. Although not constructed in the Gilded Age period, the family and their lifestyle at the end of the 19th century fit perfectly into the social structure of that time.

Not to be compared to the "cottages" of Newport, the grand summer homes of Springfield were more casual and geared to country life and lake activities. Boating, golf tournaments, horseback riding, and garden strolls were among the usual activities. Boathouses, coach houses, and stables were all part of the estates.

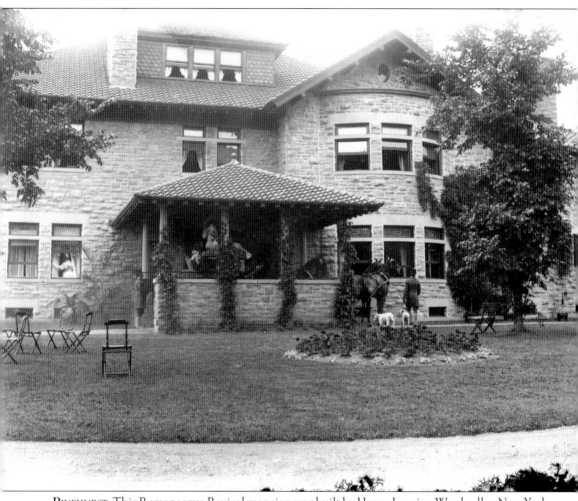

PINEHURST. This Romanesque Revival mansion was built by Henry Lansing Wardwell, a New York City stockbroker, in 1888. The impressive rough-cut grey stone structure with its corner tower, broad porch, and porte cochere, is topped with a red tile roof. Florence and Henry Wardwell summered at Pinehurst and spent their winters in New York City. Henry, born on a farm in New York, was very interested in scientific farming and raised prize-winning sheep, pigs, and cows. He employed a year-round staff to care for his animals and property. Florence and Henry Wardwell had five daughters: Rosalie, Dorothea, Alice, Minere, and Florence. All the daughters, with the exception of Florence, married and built summer homes on the property near Pinehurst. The descendants still occupy Pinehurst and several other nearby homes in the compound on Otsego Lake. (Courtesy of the Smith and Telfer Collection, Fenimore Art Museum.)

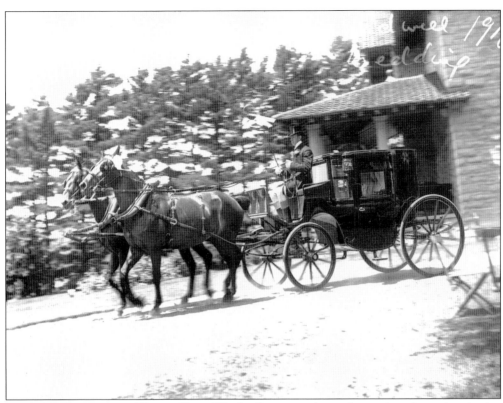

WARDWELL CARRIAGE AND HORSES. Henry Wardwell was a gentleman farmer, breeding prize-winning farm animals such as Shropshire sheep and Jersey cows, but also horses. He took great pride in his horses and had many fine carriages of various sizes and functions. Carriages were the main transport during this period. (Courtesy of the Smith and Telfer Collection, Fenimore Art Museum.)

WARDWELL BOAT. The Wardwells owned various watercraft, and this electric boat was a favorite for a leisurely summer cruise on scenic Otsego Lake. They employed many people on the estate, and it is likely that the driver of the carriage might be assigned as the driver of the boat.

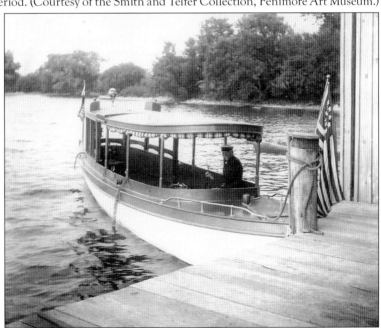

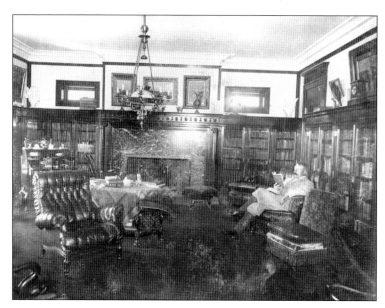

HENRY WARDWELL IN HIS LIBRARY. Nancy Smith Druse, daughter of a Wardwell chauffeur, remembers, "The billiard room leads to the library with shelves filled with many serious-looking bindings. I am sure they cover many years of collecting the classics and important literature. The library has comfortable furniture which invites you to sit quietly and read."

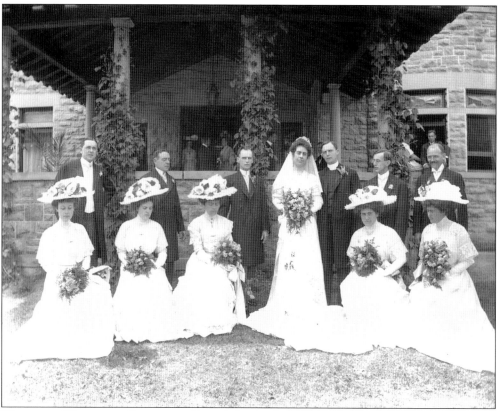

WARDWELL WEDDING AT PINEHURST. From left to right are Marshall Adams, Ruth Wellington, Thomas VanBoskerck, Minere (Wardwell) Cunningham, Conrad Howell, Florence Wardwell, Rosalie (Wardwell) Howell, Allyne Howell, Alice (Wardwell) Otis, Harrison Deyo, Dorothea (Wardwell) Wilder, and Duncan Bulkeley. (Courtesy of the Smith and Telfer Collection, Fenimore Art Museum.)

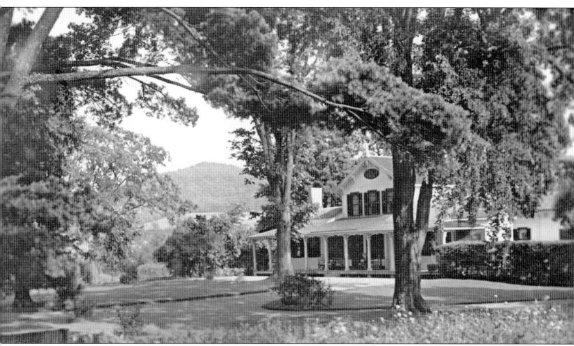

SWANSWICK. There stood a house on this site in the late 18th century, and by the 1860s, a more modern and expanded structure here was known as Swanswick. Ann Low Cary Cooper Clarke inherited Swanswick from her mother around 1830. Ann married Richard Fenimore Cooper, brother of the novelist James Fenimore Cooper. When Richard died, Ann married George Clarke, the builder of Hyde Hall. Ann left Swanswick to her son Alfred Cooper Clarke. Alfred had no children and left the property to his nephew Henry Leslie Pell, provided he changed his name to Pell Clarke. Leslie Pell Clarke married Henrietta Temple, and it is said they were charming and lively hosts and enjoyed entertaining, so Swanswick was the scene of many happy events ranging from large weddings to small dinner parties. (Courtesy of the Florence P. Ward Collection, Fenimore Art Museum.)

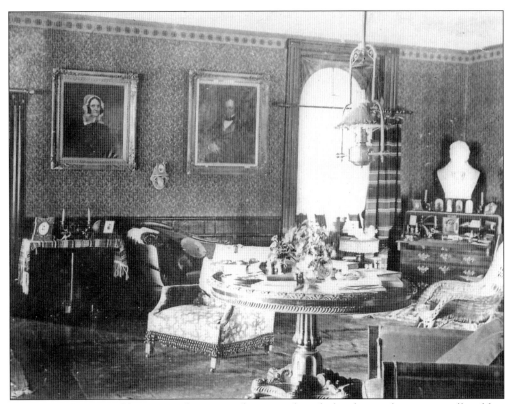

SWANSWICK INTERIOR. Victorian-style interior design, such as dark colors and eccentric collectibles, influenced the rooms at Swanswick. At the same time, the Pell Clarkes favored a casual atmosphere more suited to leisurely country living, and this combination made for eclectic interiors.

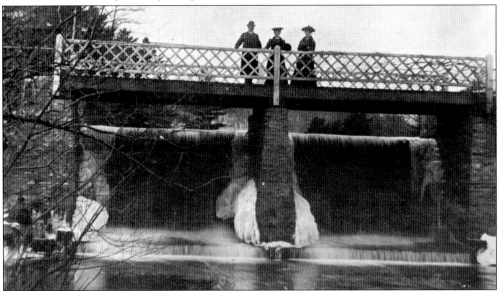

BRIDGE OVER DAM AT SWANSWICK. Life at Swanswick was very much about being in nature and enjoying outdoor activities around the lake and the golf course. These 19th-century guests enjoy a walk across the bridge that overlooks Clarke Pond. A nearby waterfall empties into Otsego Lake.

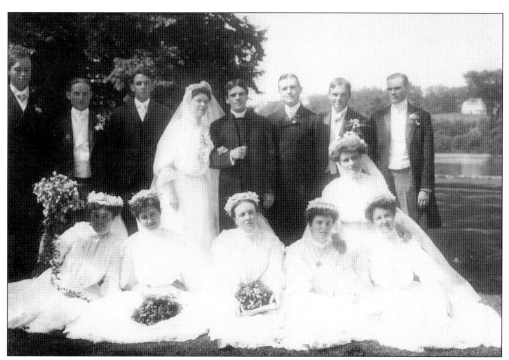

BIRDSALL WEDDING AT SWANSWICK. Ralph Birdsall (1871–1918) was the author of *The Story of Cooperstown*, one of the first books written about this quintessential American village. Married to Jessie Reid, Birdsall was the rector of Christ Church when the book was published in 1917. James Fenimore Cooper wrote the foreword to the book and described Birdsall as an "ideal historian."

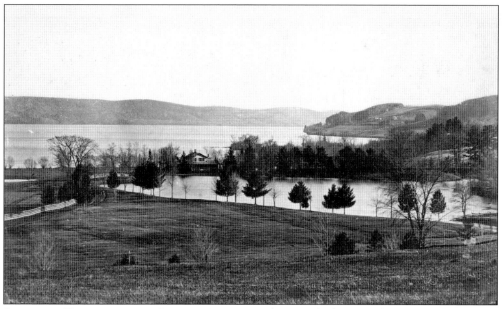

SWANSWICK VIEWED FROM THE RYERSON PROPERTY. This view, looking southeast from the Ryerson property before the construction of Route 80, shows the Otsego Golf Course, the man-made pond, and Swanswick in the distance on the shore of Otsego Lake. (Courtesy of the Florence P. Ward Collection, Fenimore Art Museum.)

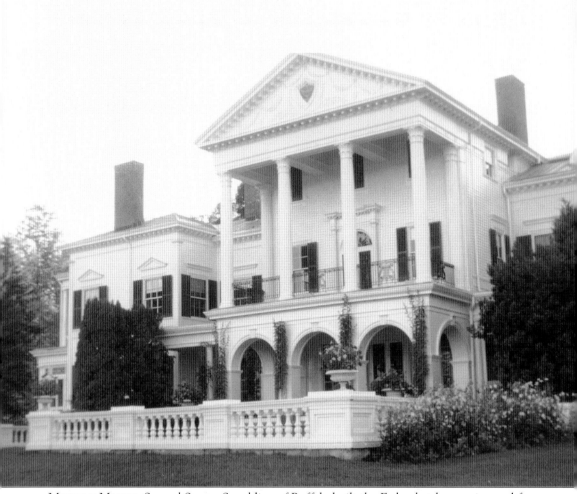

Mohican Manor. Samuel Strong Spaulding of Buffalo built the Federal-style mansion and farm complex in 1901. Perhaps the largest and most elaborate showplace on the lake, it included a three-bay boathouse, an elaborate carriage house, various outbuildings, and meticulous gardens. It is recorded that Spaulding employed more than 100 men to build the estate. The gardens, located on man-made terraces, were designed by Ellen Biddle Shipman, a pioneer in the field of landscape design. In addition to the beautiful gardens, Spaulding was a lover of horses and built a coach barn for the horses and carriages with quarters to house the coachmen. Mohican Manor was sold to the Clark Estates in the 1940s and used as a convalescent home for soldiers. Later, the carriage house was used as a summer reading school. (Courtesy of the Florence P. Ward Collection, Fenimore Art Museum.)

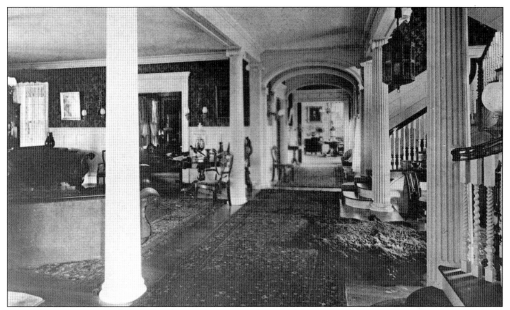

GREAT HALL VIEW. The Federalist style was influenced by ancient Roman architecture, which became fashionable in America after the unearthing of Pompeii. Interpreted elements here are the Doric columns and the arched entrance to the hallway. The double staircase contains balusters in sets of three with three distinctive designs repeated. (Courtesy of the Florence P. Ward Collection, Fenimore Art Museum.)

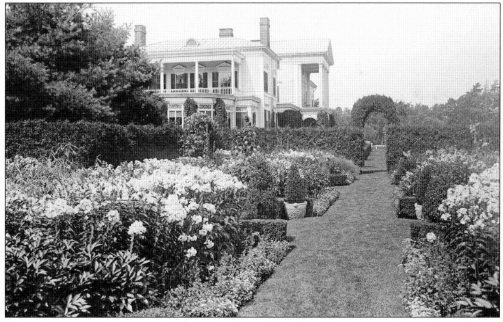

MANOR HOUSE WITH GARDENS. Landscape designer Ellen Biddle Shipman was born in Philadelphia and attended Radcliffe College. Her designs gained national recognition as she planned public gardens across the country, including the Longue Vue Gardens in New Orleans. In addition to the work she did for Samuel Strong Spaulding, Shipman created residential gardens for Thomas Edison and Henry Ford. (Courtesy of the Florence P. Ward Collection, Fenimore Art Museum.)

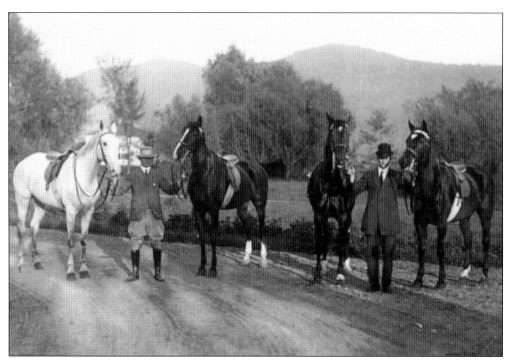

FOUR HORSES WITH GROOMSMEN. The Spauldings were avid horsemen and women and they all enjoyed riding daily. Samuel Spaulding owned many horses and employed several groomsmen. They would be expected to be on duty every day in case any member of the family wished to ride.

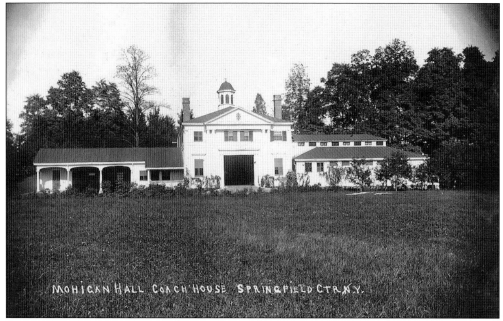

COACH HOUSE AND STABLES. Since the carriage was the means of transport in that day, the Spauldings owned many carriages that had various purposes. They would be used for both leisurely outings and trips to nearby towns. Carriages were stored in the coach house, and the horses were stabled in this building as well. The coach house also included quarters for the groomsmen and stablemen.

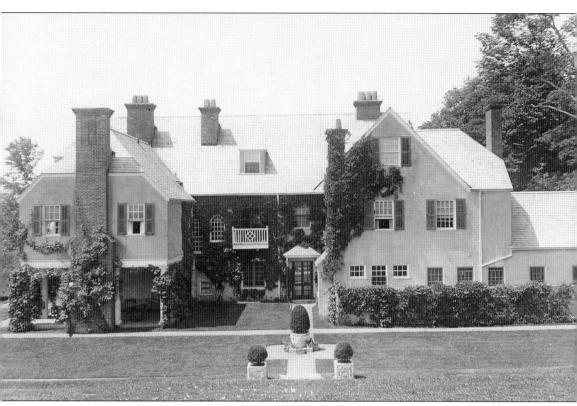

RINGWOOD MANOR. Arthur Ryerson, who earned his fortune in steel, built the English Arts and Crafts-style home called Ringwood Manor in 1901. Ryerson was lost in the sinking of the Titanic in 1912. His wife, Emily, and three of their children were also on board but were rescued. The family had been traveling in Europe when they received news of the death of their oldest son, Arthur Ryerson Jr., who had been killed in an automobile accident in Philadelphia. They booked the first available passage back to America: passage on the RMS *Titanic*. Arthur Ryerson was born and raised in Chicago. Following Ryerson's death, the family continued to spend winters in Chicago and summers at Ringwood Manor in Springfield, with its beautiful gardens and views of Otsego Lake. (Courtesy of the Smith and Telfer Collection, Fenimore Art Museum.)

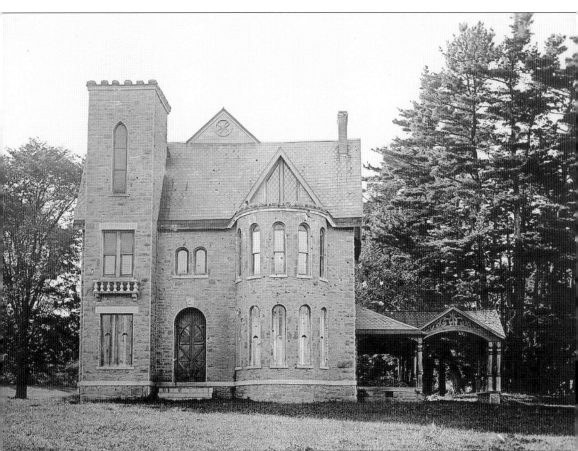

CARY MEDE. According to the *Freeman's Journal*, the original home (1889) was designed by Harriet Slayton, a graduate of the Cooper Union, who inherited the lakeside farmland from her uncle Grenville White. The castle-like structure was enlarged and altered over the years with additions, new windows, and porches. The name *Cary Mede*, "Cary's Meadow," is in part the name of Richard Cary, who held the land in the 18th century. Cary was an aide-de-camp to Gen. George Washington during the Revolutionary War. The word "Mede" is an early English word meaning meadow. In the 1920s, the property was purchased by the current owners, the Goodyear family, and enlarged again. Cary Mede, with its expansive lawn, overlooks Otsego Lake.

AERIAL VIEW OF CARY MEDE. Cary Mede today is very much as it was in the 1920s and hearkens back to the Gilded Age. This beautiful stone structure with its asymmetrical façade, irregular massing, and steep-pitched roof signals a kind of Victorian-influenced, eclectic architecture. The porch and large bay windows look out at the lake.

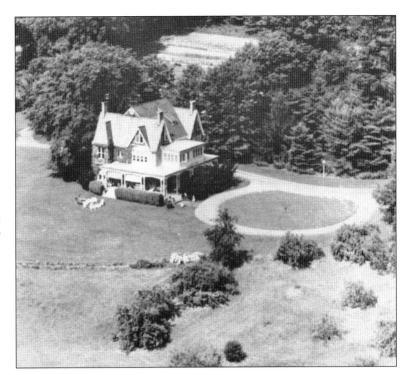

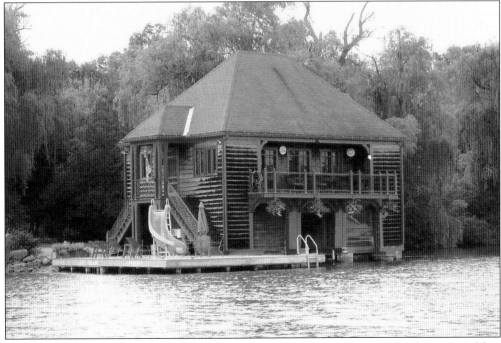

CARY MEDE BOATHOUSE. The boathouse, a two-story, three-bay structure with a bonnet roof, has a balcony on the second floor that overlooks Otsego Lake. The classic mahogany-hulled inboard boat called *Cary Mede* may still be seen cruising the lake.

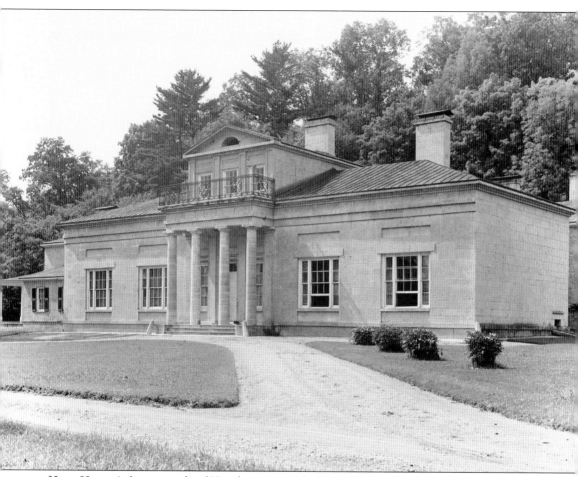

HYDE HALL. A fine example of Neoclassicism with Greek Doric columns at the main entrance, the construction of Hyde Hall took place in three stages from 1817 to 1834. Designed by Albany architect Philip Hooker, it was modeled in part on the concept of an English country house. George Clarke's great-grandfather served as lieutenant governor of the province of New York from 1703 to 1743. During this period, Clarke amassed 120,000 acres in the Hudson and Mohawk Valleys before returning to England. His descendant and namesake moved to the United States to oversee and develop his inheritance. George Clarke and his descendants occupied the house into the 20th century. Hyde Hall is now privately operated by a not-for-profit organization and is designated a National Historic Landmark. (Courtesy of the Florence P. Ward Collection, Fenimore Art Museum.)

"GENTLEMAN" GEORGE CLARKE. George Hyde Clarke and Mary Gale Carter married in 1885 and moved into Hyde Hall. When his father's bankruptcy came in 1887, the couple, with the help of her family, purchased Hyde Hall, plus 3,000 acres and many of the house furnishings. From that time until George's death in 1914 is said to have been the happiest period in the history of the house. (Courtesy of the Hyde Hall Collection.)

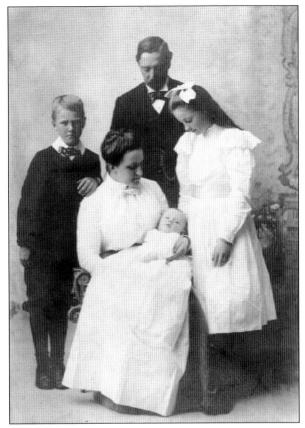

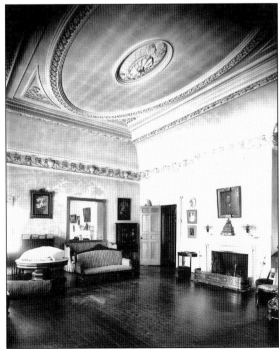

HYDE HALL DRAWING ROOM. The spacious drawing room, with its 19-foot-high ceiling and walls made to look like marble, was used for entertaining but was designed to impress. The original chandelier still hangs here and much of the furnishings are original and have been carefully researched and restored. (Courtesy of the Florence P. Ward Collection, Fenimore Art Museum.)

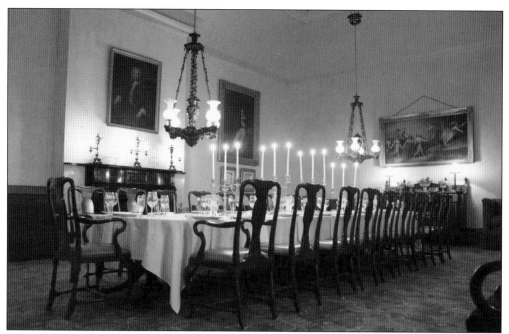

HYDE HALL DINING ROOM. The candle-lit dining room, pictured here with the table set for dinner guests, displays the trappings of the Gilded Age, including fine China and crystal. It is 34 by 26 feet, identical in size to the drawing room. Both rooms have back-loading stoves, which allowed the servants to bring in firewood without disturbing the guests. (Courtesy of the Hyde Hall Collection.)

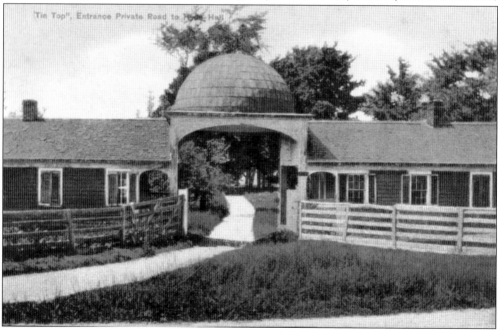

TIN TOP GATEHOUSE. Tin Top served as the formal entrance to the Hyde Hall estate. Visitors would pass under Tin Top to enter the extensive landscaped estate, traverse Shadow Brook via Hyde Hall's covered bridge then move along a scenic road to the mansion's front door. Tin Top was relocated to a site nearer the mansion and now serves as a visitor center and gift shop.

Four

INNS, RESTAURANTS, AND MARKETS

Springfield has a long history of hospitality reaching back to its founding and the development of the Great Western Turnpike. Animals, produce, and goods were moved from town to town along the turnpike, and taverns and inns were needed to accommodate travelers. Kate Gray writes in her *History of Springfield* that "there were public houses every mile or two where travelers would see teams resting under the sheds and travelers smoking in every door. The traveler driving to or from Albany, regulated his journey so he would reach the best of the inns at night. Their blazing fires, clean rooms, and well-spread tables were a source of comfort and enjoyment." In 1797 alone, there were nine tavern licenses granted. Into the 19th century, hotels were established, and accommodations were improved. In 1808, the Coates Hotel in Springfield Center was said to have a "commodious ballroom."

At a later time, in the 19th century, the introduction of railroads allowed people to escape the cities for summer retreats. The springs of nearby Richfield and Sharon Springs brought vacationers to the region, and Otsego Lake became a destination. Hotels, inns, and restaurants opened to accommodate the influx of seasonal guests. The springs were an important magnet, but tourists came to Springfield for the peace and beauty of Otsego Lake and the activities of Cooperstown. A steamboat took vacationers from Springfield down the lake to Cooperstown.

Various food markets supplied the restaurants and inns as well as the local population. Some markets made their sausage and hot dogs with meat supplied from local farms. Other markets offered fresh Otsego bass caught by local fishermen. Farmers provided an abundance of fresh vegetables including corn, beans, and tomatoes. The many orchards of the region were a source of pears and apples and cider in the fall. A healthy diet was an important part of the vacationers' rural experience.

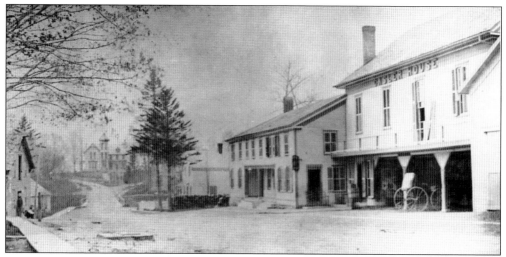

CASLER HOUSE INN. This vintage photograph of the Casler House Inn shows Springfield Center's main street as a dirt road. The wagon barn and stables next door to the Casler provided storage for the wagons and carriages and care for the horses. Looking down the road to the left, one can see the house that would become the 20th-century Toy Museum.

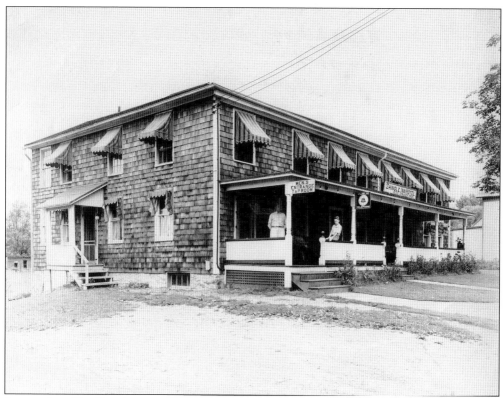

SHINGLE INN. The Shingle Inn was a popular place for vacationers and locals alike. Besides overnight accommodations, the inn contained a bar and restaurant. Pictured here is the very popular proprietor Reed Spraker with his son standing on the porch. The Shingle Inn was located where the Hayden Creek Inn is today and was previously called Casler's.

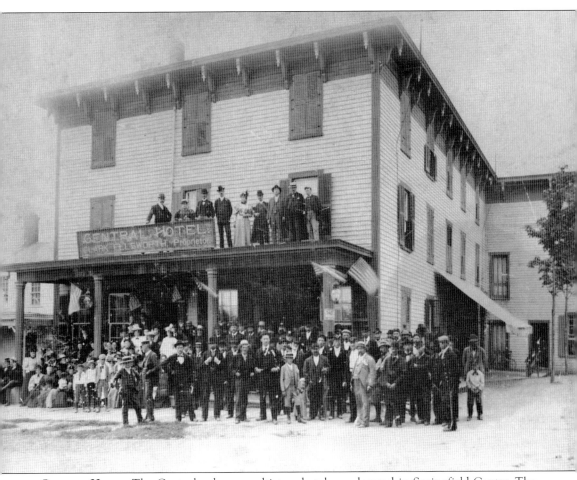

CENTRAL HOTEL. The Central, a large, multistory hotel, was located in Springfield Center. The Central is shown here on the Fourth of July in 1899, as revelers gather, with some standing on the roof, waiting for the celebrations around Main Street. It was recorded that sumptuous midnight suppers were held here, and the Sunday dinners were famous. Travel in this period was by horse and carriage or by sleigh in winter, but there was never a shortage of patrons. Clark Ellsworth was the proprietor during this period. The hotel was demolished when Route 80 was constructed.

ALA-YORK INN. Originally built in 1814 as an inn, the Beckingham Farmhouse, known as the Ala-York, was located on Route 20 west of East Springfield. It featured a tea room and served as a post office for East Springfield. Today, it is an Amish greenhouse called Shadow Brook View. This drawing was created by "Uncle" Al Eschner.

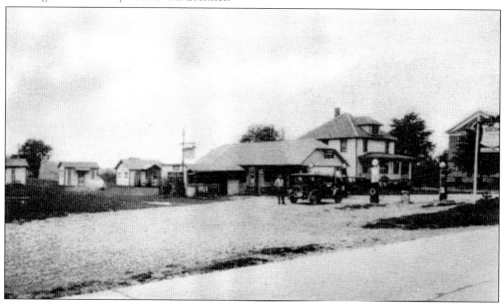

OTSEGO HILLS COTTAGE COURT. The Cottage Court featured cabins, a gas station, and a store. Tourists could fill their tanks and purchase snacks and drinks for the road or choose to stay overnight. These tourist facilities were spotted along Route 20 as it crossed the country. These were the precursors to the modern motel.

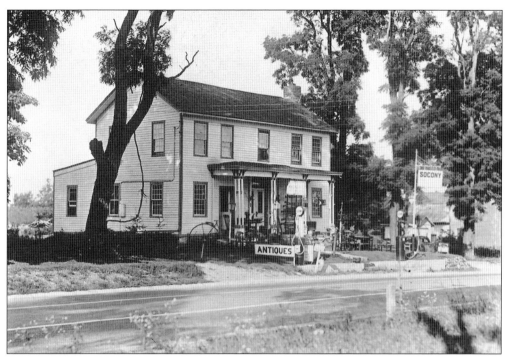

THE BLUE GOOSE INN. This inn located across from the Presbyterian church was known as a cozy and welcoming place and was famous for its hand-painted wallpaper. The wallpaper has been preserved and is now in the collection of the Winterthur Museum of decorative arts in Delaware.

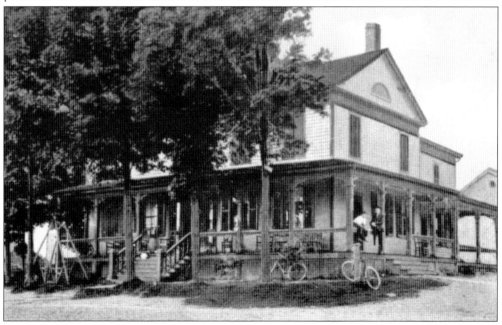

FETHER'S HOTEL. Located on the current site of KC's Diner on Route 20 at East Springfield's four corners, this hotel was previously known as the Sam Justice Hotel, which featured chicken dinners, and the Green Door Hotel. Bicycles were made available for guests to tour around the area. It burned in 1955.

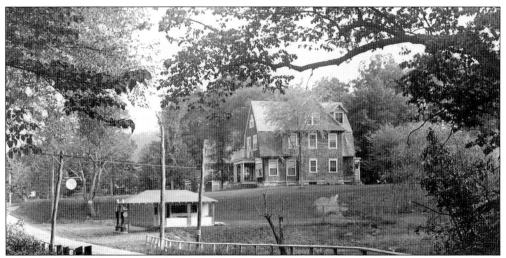

DUKE'S OAK. Delos and Miranda Pier ran an inn in this large Queen Anne–style house on Route 80 across from Mohican Farm. Duke's Oak was purchased by JoAnn Miller and Dorothy Shay, who built a playhouse in the back of the house that ran successfully for many years. The playhouse burned in 1971. The Duke's Oak house was restored by Mary Ellen and Don Fenner and remains in the family.

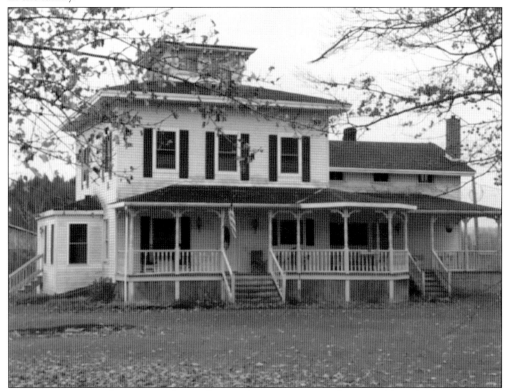

PINE BROOK INN. This inn was located near the intersection of Routes 20 and 80, next to the Convenience Corner Store. This lovely Italianate-style house welcomed overnight guests and invited diners to enjoy "food of unsurpassed quality" in "an atmosphere of charm and contentment." (Courtesy of Fred Culbert.)

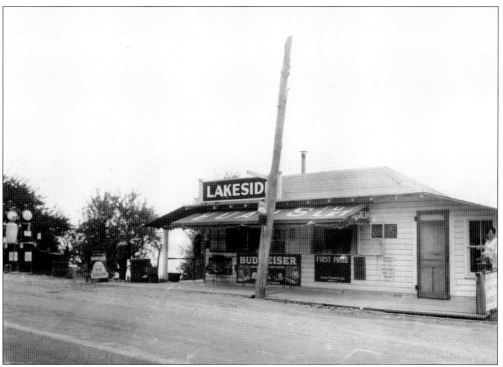

THAYER'S ROAD STAND. The Thayer family ran a roadside store and stand on Route 80, on the west side of Otsego Lake. Martha Thayer served her hamburgers on white bread. This was the perfect place for a hot dog or ice cream on a summer day.

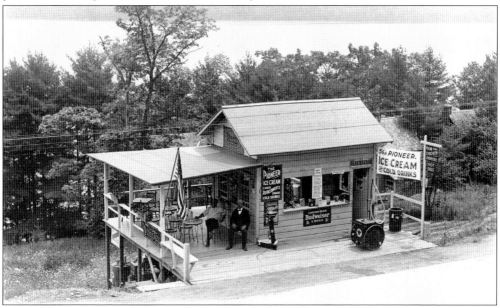

MILLER'S ROAD SIDE STAND. Miller's was also known as "the Pioneer." It was located on Route 80 near Otsego Lake. The lake side of the restaurant was screened in with sliding windows and window boxes full of begonias. Miller's was famous for homemade pies—lemon meringue, banana cream, and blueberry (when in season).

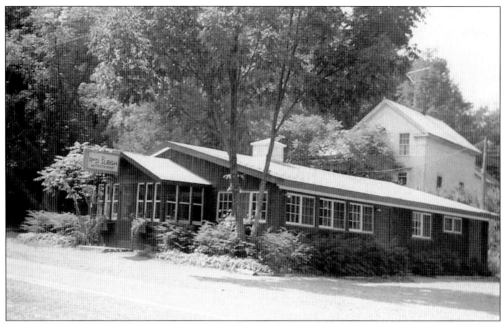

RED SLEIGH. The Red Sleigh Restaurant, formerly the Glimmerglass Restaurant, was a favorite gathering place on Route 80. It had a cocktail lounge and, later, a salad bar, and on Saturday evenings, the specialty was fried chicken. The building was razed in 2000.

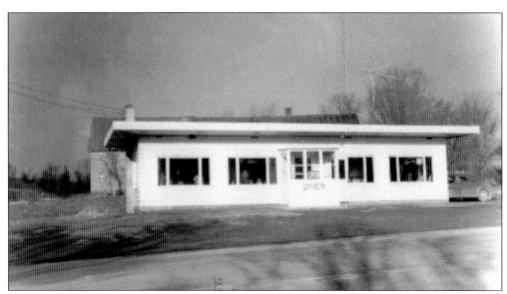

GEORGE WEINER'S DINER. Weiner's was located on Route 20 where KC's Diner is now. The diner had a bustling business between the local customers and the transient people driving along Route 20. Teenagers gathered here after sporting events for a sandwich and a cherry Coke. The diner had a bar in the back room where locals gathered to share stories.

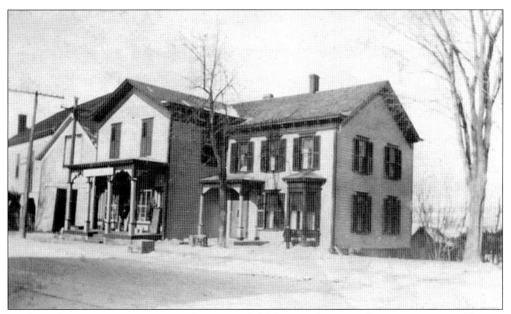

McCredy's General Store. Located in Springfield Center, this general store was operated by Ray and Frances McCredy and, later, by their daughter and son-in-law Janice and Clyde Maine. Janice is pictured here when she was a child. The McCredys lived in the house's east wing. The store was bought by Robert Duncan in 1959. The structure later burned.

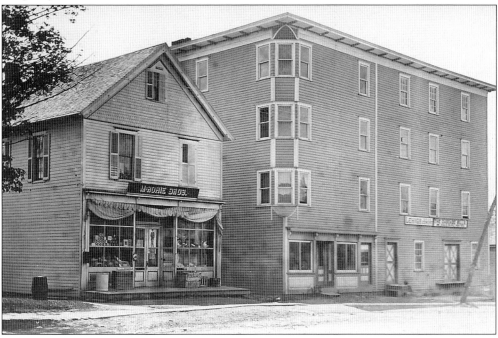

McRorie's Market. Arthur McRorie and his son-in-law, Edwin Ough, operated a retail meat market in this property located on Route 80 next to the Cascade Mill. They also sold meat from a cart that they drove to various areas of Springfield and nearby towns. This market building is now home to the Springfield Center Post Office. The Cascade Mill burned down, and that site is now a parking lot.

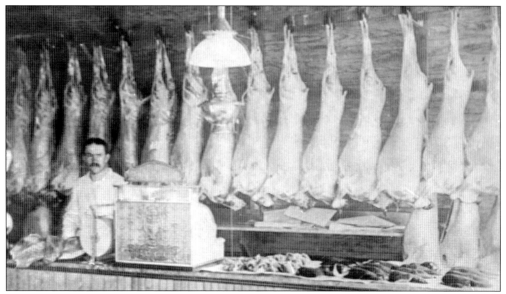

WOOD'S MARKET. Bert Wood opened his market in 1902 in Springfield Center. It was primarily a meat market offering sausage, hot dogs, and bologna that were made using smokehouse facilities located on the premises. Through the years, the store expanded. This complex was later opened as the Cherry Valley Country Store, and more recently, it was a variety gift shop known as Country Memories.

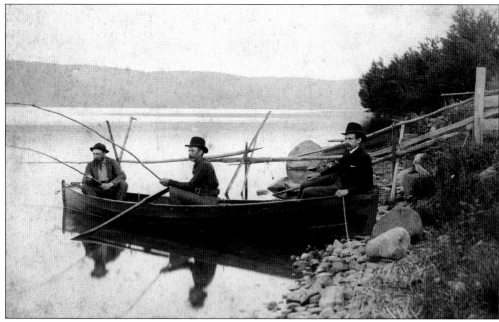

MEN FISHING ON OTSEGO LAKE. Springfield men found fishing on Otsego Lake both a pleasurable and lucrative business all year round. Otsego bass was a very popular dish in local restaurants. Woods Market bought and shipped Otsego bass to regular customers in Albany and Utica. The fishermen would arrive at Wood's at the end of the day to weigh their catches and swap stories.

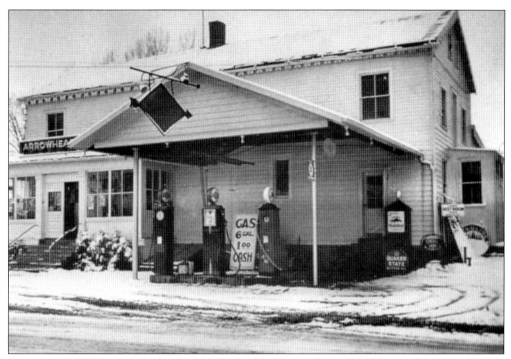

SEWARD'S—AND THEN ROBELIN'S—STORE. This building, erected around 1801, was located at the four corners in East Springfield. The building was owned and operated by a succession of people—Robert Ormiston, Adelbert Seward, Roy Flint, and Benjamin Robelin. Gas was six gallons for $1 in the day. Note the Arrowhead sign to the left.

SEWARD'S ARROWHEAD STORE. Pictured here is Adelbert Seward with his staff in 1880 inside the Arrowhead Store. The store carried general home merchandise such as lamps and dishes as well as groceries and preserved foods. Pickles preserved in a big oak barrel were a common product of the time. The pickles were prized for their texture and flavor, and the oak cask doubled as a seat.

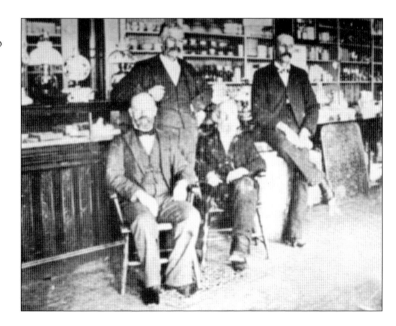

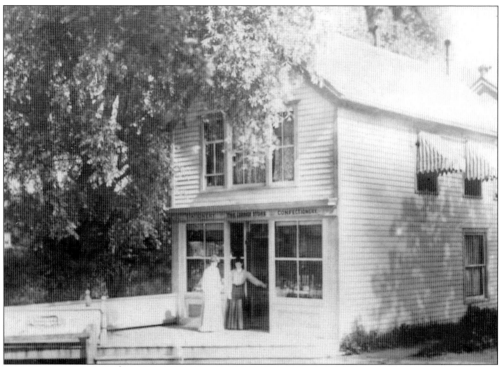

WILLOW'S STATIONERY COUNTRY STORE. Willow's was also called "the Corner Store" and sold candy and school supplies. It was popular with local students because the Union School was just down the lane along Hayden Creek. The two women in period dress date this photograph to the 1880s.

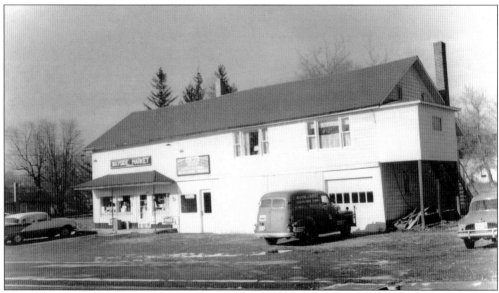

WAYSIDE MARKET. A similar corner store in the next century, the Wayside market was located on the north side of Route 20 in East Springfield and housed a plumbing and electric supply company on the east side. The Wayside, also known as Yerdon's, sold general groceries, some fresh fruit and vegetables, beer, and soda.

Five

EARNING A LIVING

If one stands at the top of Mount Wellington or Rum Hill, or if one floats on the surface of Otsego Lake and dreams of its bottomless depths, it would seem that Springfield is a timeless place, not locked into any century or decade. But Springfield, like all of America, is subject to the advances and inventions incurred with the passage of time. Springfield has been fortunate to have taken the best progress has to offer while maintaining its bucolic charms.

Businesses around Springfield changed and adapted as the region evolved from a western frontier town to a farming community. Taverns and inns were built to accommodate travelers passing through on Route 20 and those visiting the lake and surrounding area.

Mills were built to provide the lumber needed to build houses and barns. Farming of animals and crops necessitated the clearing of portions of the vast forests of Otsego County. Blacksmith shops sprang up to meet the needs of the farms and other businesses.

The invention of the automobile and mechanized farm equipment certainly changed the American landscape, and Springfield was no exception. Gas stations and repair shops were built to meet these needs. The mobility provided by the automobile also influenced the shape of small towns as easy access to larger cities and malls tended to centralize consumer stores.

Through all the great changes across American society, Springfield, though altered, remained primarily a farming community. The crops planted have changed through the years from hops to corn and wheat and soybeans. Much of what is grown is feed for the farm animals. The animals farmed have shifted from food sources to dairy and back again.

In more recent years, consumer interest in locally sourced and organic meats and vegetables has given rise to new farming trends. Demand for dairy products increased with the growing popularity of yogurts and specialty cheeses including artisan goat and sheep cheeses. Smaller specialty farms have come into being to supply farm market stands and farm-to-table restaurants. The farmer, known through history for resilience and self-sufficiency, remains at the core of what makes Springfield a special place.

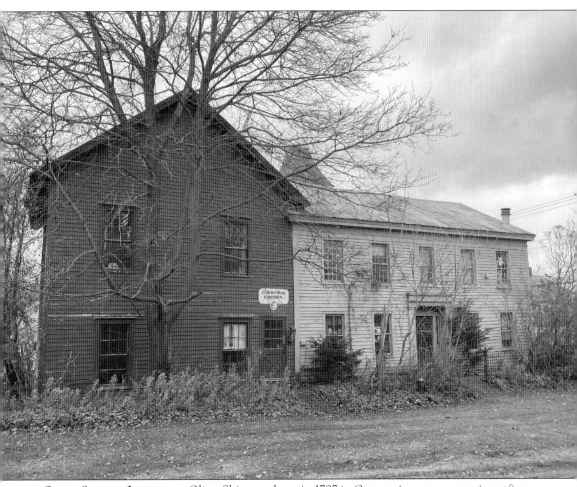

OLIVER SHIPMAN INDUSTRIES. Oliver Shipman, born in 1797 in Connecticut, was a prominent figure in Springfield history mainly because he was the founder of the Spring and Axel Works, an important industry that employed many men. In addition, Shipman invented and manufactured the Shipman plow, was a leader in the building of the Plank Road, organizer of the Universalist Church, and donor of the land on which the church was built. He also established a hotel in Springfield Center. Shipman married Saphrona Whipple, and they lived on the main street of Springfield Center in the large farmhouse pictured here. Following Oliver's death, Saphrona sold the house to Leslie Pell Clarke, who turned it sideways so the narrow end faced the street. Clarke deeded the building to the village, and it became the beloved and very popular Club House. (Photograph by Nora Crain.)

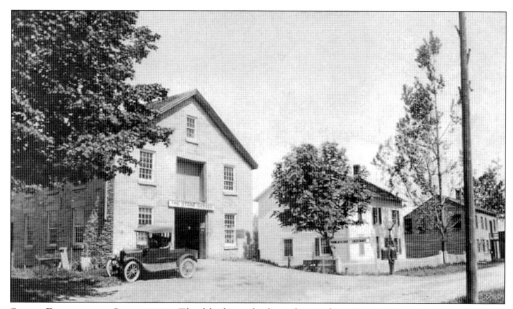

STONE BLACKSMITH SHOP, 1873. The blacksmith shop, located on Route 31 in East Springfield, was constructed prior to 1872. Daniel Butts sold it to Chester Frisbie, who sold it to Edward and Alfred Francis in 1873. In the 1920s, it was used as a feed store and, later, a machine repair shop. Owen Fassett purchased the building in 1942, and in 1972, it was conveyed to Kermit and Myron Fassett, who sold it to Betty and Dean Fassett.

JOHN OLIVES BLACKSMITH SHOP. This blacksmith shop was located on Hayden Creek near the main street of Springfield Center. The waterwheel indicates it had been a mill in earlier days. The Baptist church can be seen in the distance. Today, the building has been converted into an artist's studio.

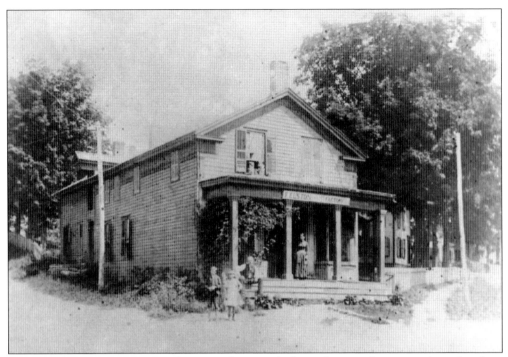

FRED ELSTON'S CIGAR FACTORY. This 1882 photograph shows the cigar factory on the right where the present-day firehouse is located. The building was, for many years, a store owned in succession by Sid Ayers and then Dick McRorie, both of whom would own other stores in Springfield Center.

VANDERVEER'S HARDWARE STORE. Located in Springfield Center, the hardware store carried not only nuts, bolts, and hinges, but also the goods needed for every imaginable project an early Springfield resident might undertake. This photograph shows the ubiquitous Doc Swanson standing in front. "The Doc" could be found around town and in the Club House daily.

A.J. Ayers Cash Store. Ayers was a general merchandise store that carried clothing and hats as well as some grocery items such as flour and sugar. It was located in Springfield Center. The photograph captures a seemingly mundane moment in Springfield's everyday history, picturing a man with a horse, a woman holding a cat in her arms, and children on the porch of the shop.

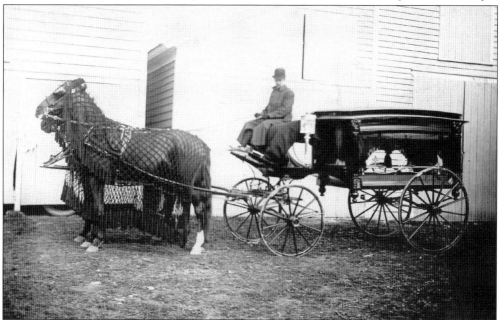

Grigg's Casket Company. In the 19th century, casket making evolved from cabinet making, and the craftsmen often doubled as undertakers. The double duty is illustrated here, as the horse-drawn wagon carries a casket from Grigg's Casket Company located on Griggs Road. The horses are draped in black netting to symbolize the mourning of the deceased.

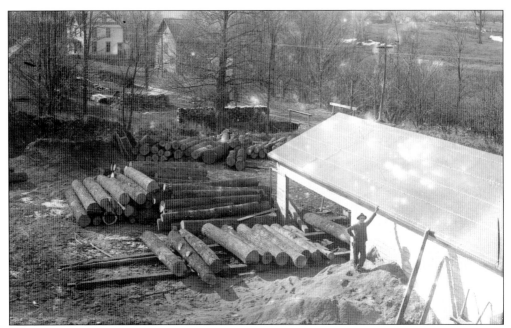

VIC HOKE'S LUMBER MILL. The lumber mill was an important asset to a growing community. Springfield was rich in forests that needed to be cleared for farming, and the wood was needed to build houses and other structures. This lumber mill was located on Route 80 in Springfield Center. Hoke is shown standing next to the building.

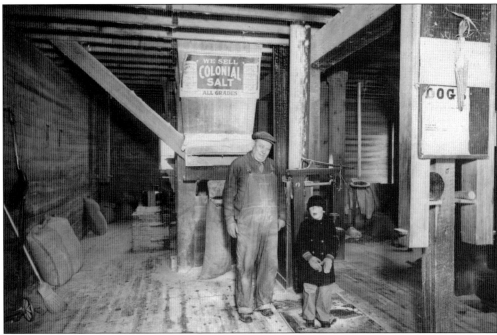

CASCADE MILL. Farmers would bring their grain to the Cascade Mill to be ground into flour. Some farmers would sell their grain to Cascade, which, in turn, would sell the flour to bakers. Pictured here are Henry Hecox (left) and his little helper Leslie Stocking. Cascade Mill, located near Hayden Creek, burned in September 1954.

TRUMAN WILLIAMS CUSTOM SAWING. The introduction of steam- or gasoline-powered engines allowed the sawmill to be mobile. Williams' operation, shown here at Fred Smith's, used the logs on the client's property to custom-mill the wood needed. Truman Williams (1872–1950) married Maude Wiltse and lived on Doyle Road in Springfield. He crafted wooden whirligigs and other fanciful carvings—some of which are in the collection of the Springfield Historical Society.

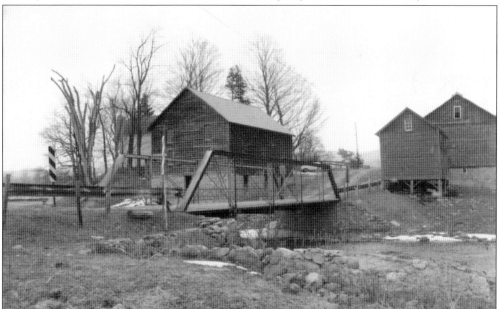

RATHBUN MILLS. In the early days of Springfield, wherever there was a moving stream there would likely be found the essential sawmill or gristmill, so important was this industry to the region in that period. The Rathbun Mills were located on Shadow Brook on Rathbun Road. The descendants still live on this property.

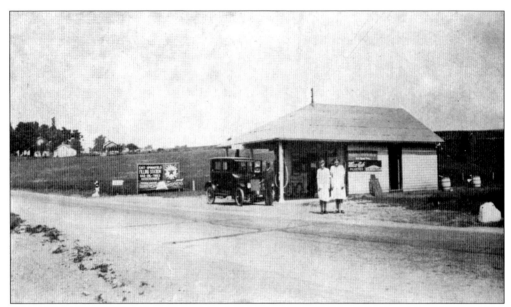

MONK'S SERVICE STATION. Monk's Station was located on the north side of Route 20 in East Springfield just before Shadow Brook. The Gray Farm is visible on the hill. This Texaco station featured a sheltered area to pump gas and a shop that sold beer and ice cream. The two ladies are posing for the camera before returning to their road trip down Route 20.

MERLE THOMPSON'S STATION. A very early Mobile Oil Station, located at the southwest corner of routes 20 and 80, Thompson's contained a small shop where tourists could buy snacks. It was gone by the end of World War II and is now the property of the Springfield Cemetery Association.

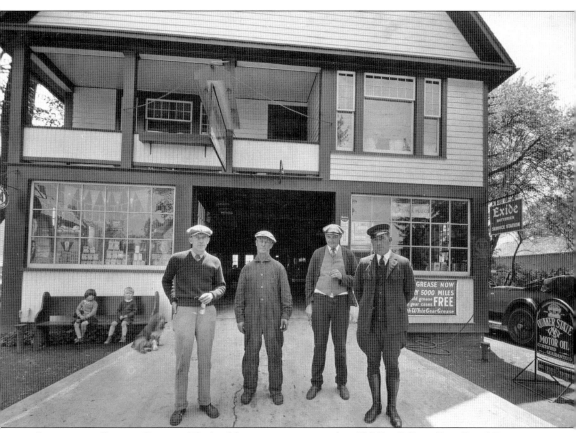

SPRINGFIELD CENTER GARAGE. The building was constructed in 1917 by Gilbert Engell and Stewart Wheeler and housed various stores, including Conklin's Millinery Shop, which is pictured on the cover of this book. In later years the building was converted into a garage. The garage passed through many owners, including Edwin Kelly, Glen Griffith, Harry Miller, and Bill Schultz, whose name is still on the signage: Bill's Garage. His son Dale now owns and operates the business. Pictured in this photograph, according to Janet Gray, are, from left to right, Stewart Wheeler, an unidentified mechanic, Hawley Carey, and Mike Doyle, known about town for his skills at golf and baseball, here dressed in his chauffeur's uniform. Stewart Wheeler's son Pete is one of the children seated on the bench on the left.

CHARLES MCFEE'S AND THEN CRAIN'S SUNOCO. Robelin's was torn down and replaced by a Sunoco gas station known as McFee's, then Burnside's, then Crain's. It is now a small engine repair shop owned by Nathan Prime, located on the northeast side of Route 20 in East Springfield.

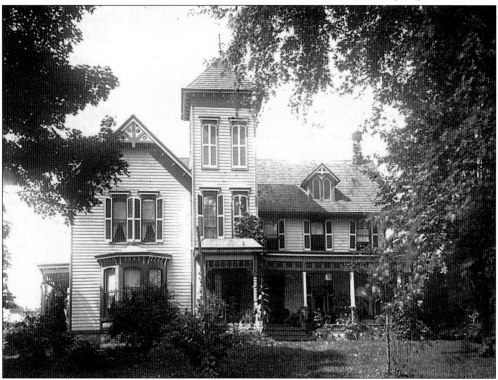

DENNY'S TOY MUSEUM. This mid-20th-century museum was located in a 19th-century house at the fork known as Olives Point near Smith Road in Springfield Center. Collections of toys, dolls, electric trains, and children's games were on display for the admission price of 50¢ for adults and 25¢ for children.

Six

ORGANIZATIONS AND CLUBS

Social organizations, the establishment of which seems to be a defining characteristic of human nature, are certainly essential to a small town. They make available opportunities for interpersonal relationships, assure community support for the individual, and provide for the care and safety of individual members of the group and the town as a whole.

Beginning in childhood with groups such as the Girl Scouts and the Boy Scouts, and moving through all ages and stages of life, organizations play an especially important role in a rural community. Springfield had two farmers' associations: the Grange and the Farm Bureau. Locals celebrated their heritage and patriots through organizations such as the American Legion and the Daughters of the American Revolution. They entertained themselves and each other with baseball teams, golf teams, and various bands.

Springfield had two buildings in particular, in the old days, which served the town's residents and their organizations. The town hall, built in 1903, and the Club House, built in 1912, both contained rooms to fulfill various group functions. The town hall was designed for larger gatherings such as plays and graduation ceremonies. The Club House provided space for smaller gatherings and entertainment such as card games, billiards, and bowling.

Today, the Springfield Community Center, located in the 1958 former elementary school, houses the town offices, the library, the historical society, the Leatherstocking Brush and Pallet Club, meeting rooms for exercise groups and book groups, and an auditorium for larger gatherings. The support derived from organizations is essential to the locals' well-being and the glue that holds the town together.

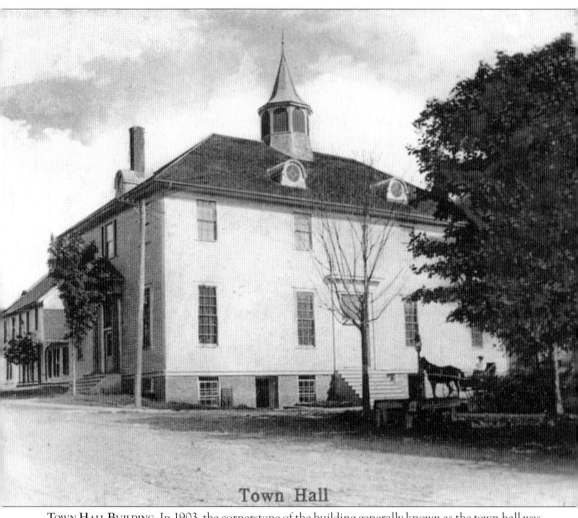

Town Hall

TOWN HALL BUILDING. In 1903, the cornerstone of the building generally known as the town hall was laid. The building was to be the meeting place for two organizations: the Masons of the Evergreen Lodge and the Social Service Guild, a women's organization associated with the Episcopal Church. The construction was supported by Leslie Pell Clarke and Andrew Smith. The building was 42 wide by 72 feet long. The first floor was to be used as an opera house where various entertainments took place, including minstrels, talent shows, and dances. School plays and graduations were held there as well. The second floor would be for gatherings of the Masons and the Ladies of the Eastern Star. The horse-drawn wagon in front dates this image to the time of the building's founding. The building is now privately owned.

CLUB HOUSE, 1912. Located in Springfield Center between the Baptist and Episcopal Churches, the building was previously Shipman's Home. The Club House contained a club room for cards and other activities, a bowling alley, a billiards room, and a barbershop. Various social activities and town events were held here.

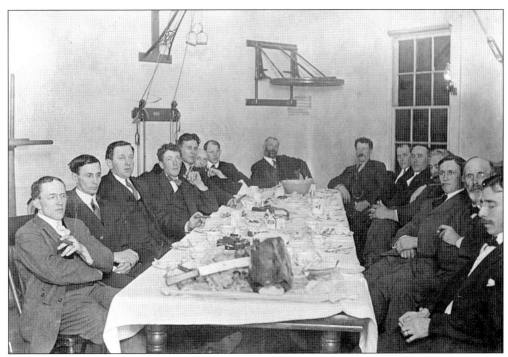

DINNER IN THE CLUB HOUSE. This gathering in the gym of the Club House around the time of its opening included "town fathers" (left to right) Bert Wood, Kenneth Gros, Victor Gros, Oliver Smith, Carl Douglas, Morris Hecox, Frank Smith, Fred Maxted, Fred Smith, Henry Hecox, Gilbert Engel, Clifford Hinds, Raymond Ough, Doctor Swanson, and Fred Harmon.

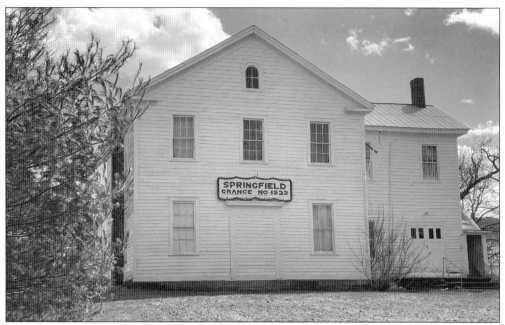

THE GRANGE. The Grange No. 1523, a farmers' association, was organized in 1932 and held its first meeting in the Clinton Library in East Springfield. Later, they purchased the building pictured here, which was originally the Springfield Academy from which Owen D. Young graduated. Young was the founder and President of RCA. The Grange was known for regular card parties and square dances held as fundraisers. The election night supper was a big annual event.

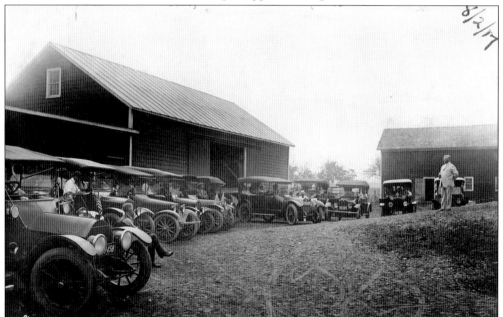

FARM BUREAU. The Farm Bureau met in Springfield regularly to educate and advocate for farmers. The group's mission was to improve income for farmers, thus having a positive impact on the region. This 1917 photograph shows a gathering of farmers with their period automobiles at Frank Smith's farm (known as Broad Acres), which was located on Smith Road.

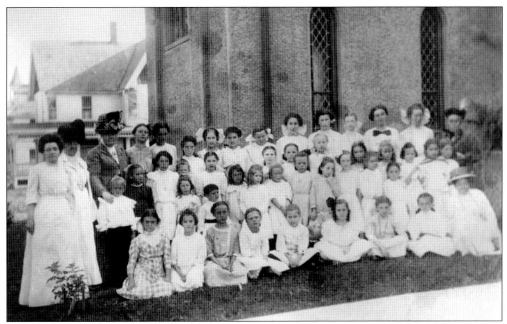

SPRINGFIELD SEWING SCHOOL. The sewing school was organized in 1891 by Florence Wardwell and Cora Blunck at St. Mary's Episcopal Church. Children were taught basic sewing skills, beginning with simple stitching techniques and moving on to more difficult projects. The season would end with a large party with games and refreshments at the Wardwell estate, Pinehurst. The sewing school disbanded at the beginning of World War II.

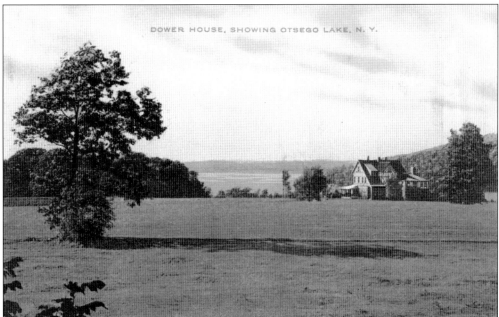

DOWER HOUSE AND THE ETHICAL CULTURE SOCIETY. This Tudor-style house was located on the southeastern shores of Hyde Bay across from Hyde Hall. Anna Clarke built her home around 1890. In the 1920s, the house was leased to the Ethical Culture Society, which ran a summer camp there for decades. Later, the house fell into disrepair and was demolished.

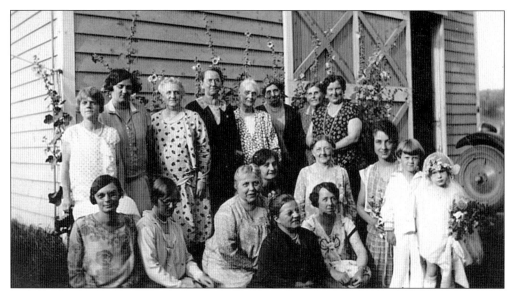

DAUGHTERS OF THE AMERICAN REVOLUTION. Members of the DAR share the common bond of having an ancestor who was a patriot in the American Revolution. Early Springfield residents had an important place in the Revolution. The DAR of East Springfield, pictured here at the Grange, held its early meetings in the Clinton Library. The DAR, in cooperation with the American Legion, placed flags on the graves of local veterans. The fire department continues this tradition today.

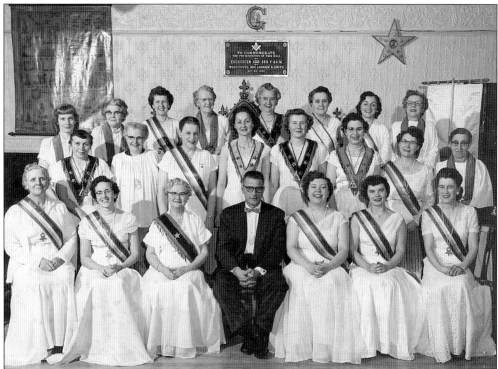

EASTERN STAR. This gathering of the Order of the Eastern Star was held in the Masonic Temple on the second floor of the town hall. The group was an appendant of the Masons. The women are dressed in gowns with ribbons across their breasts, which may indicate an initiation ceremony.

AMERICAN LEGION MCSHANE BUDDLE POST. A group of veterans, brought together by Charles Doyle and Walter Ough, met at the Club House in 1946 to form American Legion Post No. 1503 in Springfield Center. Bill Linney, a veteran of World War I, explained the requirements of the organization and benefits to the veterans. The post was named for John McShane and Kenneth Buddle, who gave their lives in World War II.

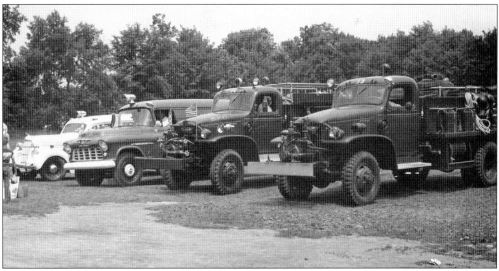

FIRE DEPARTMENT. The first fire department in Springfield, the Rescue Hook and Ladder, was incorporated in 1891. Their equipment consisted of a horse-drawn cart with one hose. In 1946, the present fire company was incorporated. Springfield's fire department is a completely volunteer organization that formerly consisted of two companies: No. 1 in East Springfield and No. 2 in Springfield Center.

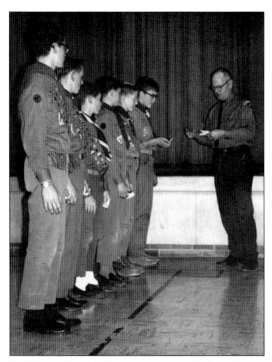

BOY SCOUTS. Troop No. 47 of Springfield Center provided opportunities for the boys to camp and hike in the regional forests and to meet any challenge presented. The scouts pictured here were being awarded merit badges for the accomplishment of special projects. Ed Walton and Ken Ainslie were long-serving scoutmasters.

GIRL SCOUTS. The Girl Scouts and Brownies of Springfield gathered here for a fun "paint the sticks" event, attaching meaning to the symbols of color and shape. The group would regularly participate in field trips and various educational adventures. Shown here are (left to right) Rebecca Beckingham, Christine Culbert, Tracy Goodrich, Claudia Yager, Dawn Bodmer, and Brownie Kathy Culbert.

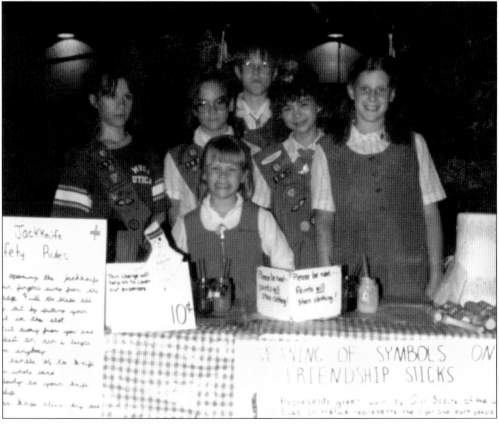

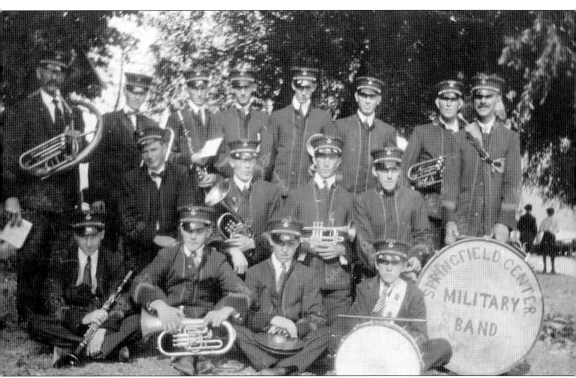

SPRINGFIELD CENTER MILITARY BAND. Springfield's military band was an ensemble composed of both wind and percussion instruments and was capable of playing ceremonial music, national anthems, and patriotic songs, as well as traditional marching music. In this case, the term "military band" applies to a civilian band that is scored as a military band. Organized in the tradition of the brass and woodwind band, they were especially good at marching music and they regularly participated in the Springfield Fourth of July Parades. In addition to marching back in the day, the band would perform the National Anthem at the raising of the flag at the Fourth of July ceremonies. They also performed in concerts and would entertain the audience by playing the popular music of the period. The drum pictured here is in the collection of the Springfield Historical Society.

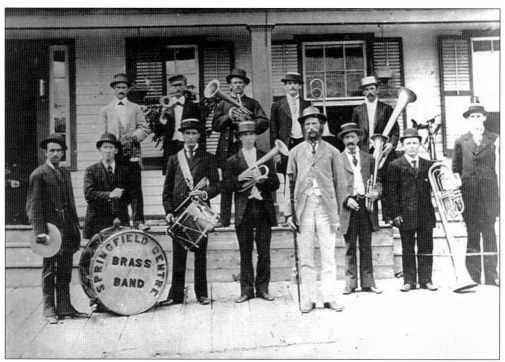

SPRINGFIELD CENTRE BRASS BAND. The brass band, a musical ensemble, consists of various brass instruments plus percussion instruments to keep the beat. The Springfield band consisted of nine horns, two drums, and cymbals. The brass band is an old English tradition, and that tradition is indicated here by the spelling of the word "Centre." The drum major holds a large baton.

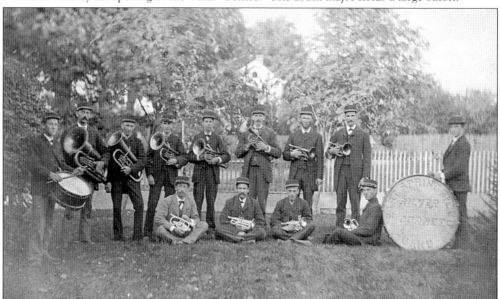

EAST SPRINGFIELD CORNET BAND. The 11 brass musicians assembled here are all cornet players. Matched with two drummers, the group is dressed in their uniforms with matching hats. The cornet is the most numerous instrument in the brass band, and some of these musicians played in all the local bands.

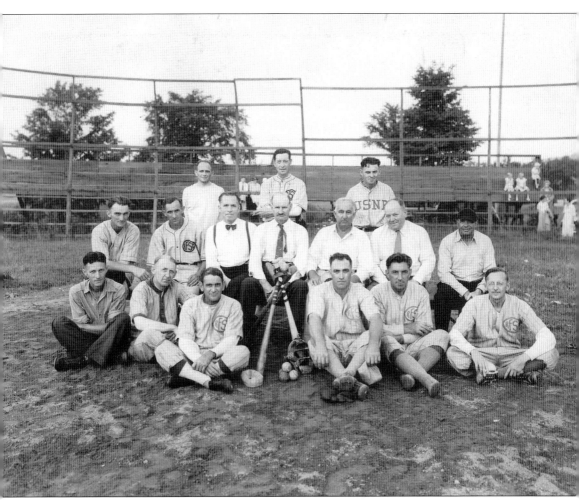

BASEBALL TEAM. This local baseball team was composed of men from the towns of Springfield and Richfield Springs and the Village of Cooperstown. The men are dressed in a variety of uniforms; the classic wool pants and high socks being the favored "catch-as-catch-can" unofficial outfit of the day. The bats and gloves are carefully positioned for the photograph and provide, in themselves alone, a walk down memory lane. Cleat shoes were popular. Games were often a family affair with wives and children filling the bleachers. The list of local heroes pictured here includes many familiar Springfield names. Pictured are, from left to right, (first row) Robert Gros, Pete Johnson, Harry King, Fred Sloan, Mike Doyle, and L. Gros; (second row) Edgar Hyer, Charles Sloan, Robert Smith, Clarence Breese, Clifford Hinds, Henry Hecox, and Charlie Peters, umpire; (third row) Bob Hecox, Leland Smith, and Russell Vanderburg.

SPRINGFIELD HISTORICAL SOCIETY. The mission of the Springfield Historical Society is to collect and preserve the material culture of the town of Springfield, exhibit and interpret the history of the town and its people for the general public, and offer educational programs and events. The Historical Room contains a "Discovery Center," a hands-on teaching collection of historical books and games for children. The society mounts changing thematic exhibitions using objects from the collections and related programming designed to enhance the visitor experience. All lectures and associated events are free and open to the public.

Seven

AROUND THE LAKE

James Fenimore Cooper mused in his 1838 *Chronicles of Cooperstown* about the beauty of Otsego Lake and the surrounding area and wrote that he expected that "half a century hence, the shores of the lake will be lined with country residences." It was a somewhat prescient thought, because by 1888, there would be some great estates established on the north shores of Springfield. The stagecoach business would carry passengers from Richfield Springs to meet the steamboats at Steamboat Landing in Springfield, and local inns would offer accommodations and meals to vacationers. By the turn of the century, various kinds of camps had developed around the lake, ranging from rustic tents on platforms to two-story houses with sleeping porches and balconies, inviting the outdoors in. Camp owners paid tribute to the novels of James Fenimore Cooper and his beloved Glimmerglass by assigning names to the camps like "Hutter's," "Pioneer," "Judith," and "Mohican." Campers received their provisions and mail via the steamboats and could travel to the village for a day.

In 1894, Leslie Pell Clarke and Henry Wardwell together would build the Otsego Golf Course while other summer games, such as tennis and croquet, were available to play around the lake. Rowboats and canoes were kept by the camps for short excursions, and sailboats were also widely available.

By the turn of the 19th century, children's camps began to develop. The Girl Scouts and Boy Scouts, YMCA, Ethical Culture Camp, and various other religion-affiliated camps sprung up.

With the invention of the automobile, access to this rural area and the lake was made easier. Summer cottages and bungalows were built for weekly or monthly rentals and supplemented the hotels and inns. Hyde Bay Colony is an example of a cluster of camps oriented to the lake, which provided extended family accommodations where vacationers could cook their own meals and have easy access to swim and boat on the legendary Glimmerglass.

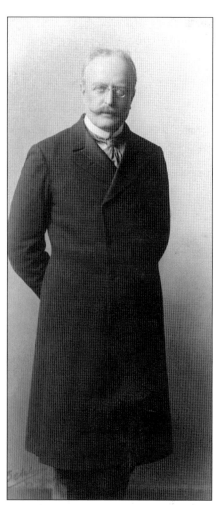

LESLIE PELL CLARKE, 1902. The driving force behind the establishment of the Otsego Golf Course, Leslie Pell Clarke was an avid golfer in a time when golf was a little-known sport. In 1894, there were fewer than a dozen golf courses in the United States. Pell Clarke's outgoing and jovial personality was said to be greatly responsible for the success of the club.

GOLF COURSE CLUBHOUSE. The Otsego Golf Course clubhouse was built in 1894 at the head of Otsego Lake. The building has a broad porch, expanded a few times over the years, that provides room for outdoor dining with a spectacular view of the lake. Golf enthusiasts would take the steamboat from Cooperstown to Springfield to play what was then a novelty game.

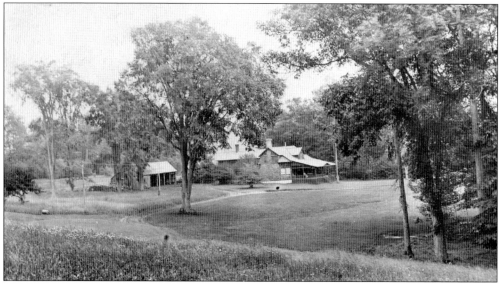

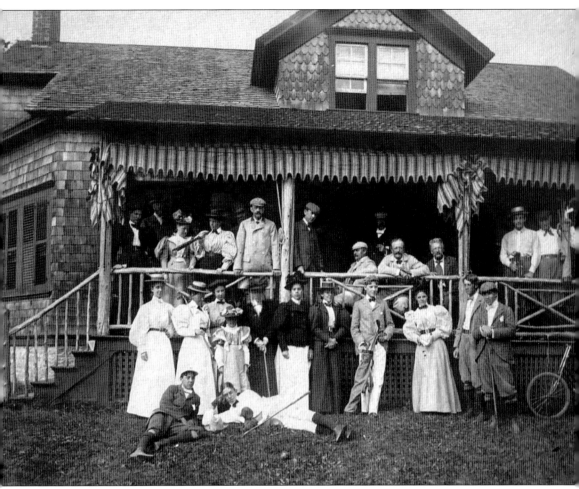

OTSEGO GOLF CLUB FOUNDERS, 1896. The Otsego Golf Club was established by two men who owned the land at the northern end of the lake where their manor houses were located. Leslie Pell Clarke of Swanswick and Henry Wardwell of Pinehurst combined their land and resources to create the golf course. The founders are pictured here on the Adirondack-style porch with awnings, a familiar feature of the clubhouse. At the center of the group is Leslie Pell Clarke, with his arms resting on the railing. Henry L. Wardwell is just to Pell Clarke's right. George Hyde Clarke, Arthur Ryerson, and Samuel Spaulding, all men who owned mansions at the northern end of the lake, were also enthusiastic supporters of the club. A. Beekman Cox, a resident of Cherry Valley, was another regular. This photograph shows men with their golf clubs at the ready and ladies in straw hats.

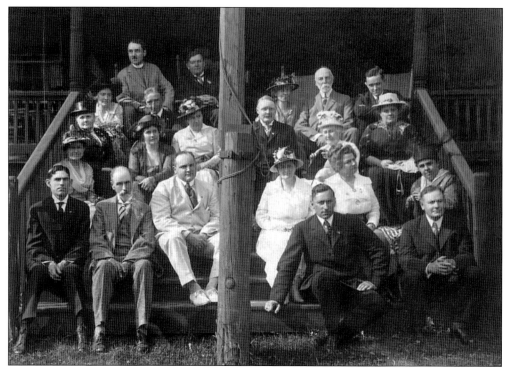

LUNCHEON, 1917. The clubhouse became a social center, a place to host parties and entertainment. Thomas and Marie Proctor invited friends for an afternoon luncheon in the summer of 1917. Pictured are people whose names were familiar in Springfield and Richfield Springs: Bloomfield, Soare, Mungor, Cary, Welden, Losee, Winne, Swift, Williams, McKee, Steele, and Tunnicliff.

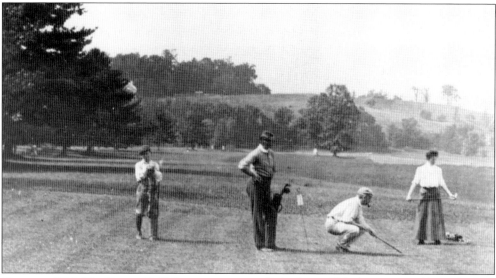

GOLFERS, 1900. The Otsego Golf Course was originally built as a 12-hole course and later changed to a 9-hole layout with blue and white tees for 18 holes. It was designed by Devereux Emmet, a pioneer in the field. The caddy shown here is dressed in the traditional golf outfit of "knickers," cotton stockings, and woolen cap while the men are more casual in long, loose-fitting wool pants and shirtsleeves.

JACK RYERSON AND HIS WIFE, JANE MORRIS. An ardent golfer, Ryerson spent his summers at Ringwood Manor in Springfield and played the Otsego Course. For the first 48 years of its existence, the golf course was a private club, but Ryerson had a list of people of limited means who could play the course for free. In 1942, Ryerson opened the course to nonmembers for a daily greens fee.

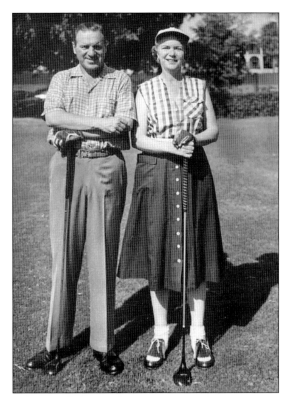

OTSEGO GOLF CLUB TEAM. Seated on the clubhouse porch around 1949 are, from left to right, clubhouse team members Charles Sloan, Mike Doyle, Jack Ryerson, William Quaif, and William Quaif Jr. Following the death of Leslie Pell Clarke in 1904, Arthur Ryerson took the lead as course manager. After Arthur Ryerson passed in 1912, Samuel Spaulding took over, and later, Emily Ryerson managed the course. Her son Jack later assumed control of it.

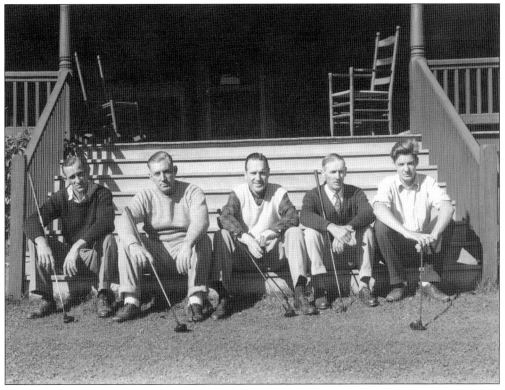

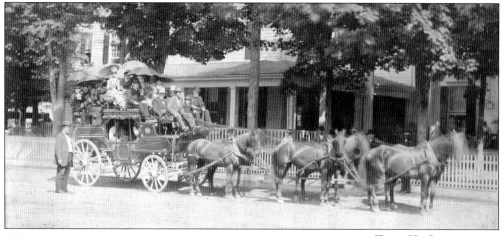

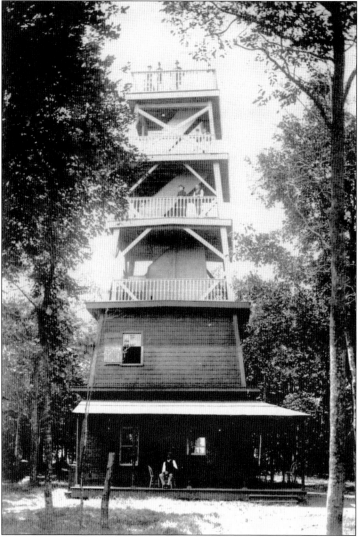

TALLY HO STAGECOACH AND RUM HILL TOWER. In the late 1800s and into the 20th century, there was a stagecoach service between Richfield Springs, a very popular summer spa town, and Springfield's Steamboat Landing, also known as Colburn's Landing. Vacationers would travel by horse-drawn coach to the landing, usually with a picnic stop at the Rum Hill Tower where, for a modest fee, one could ascend to the top for a most spectacular view of the Adirondack Mountains and a view of seven lakes. Following the picnic lunch, the group would continue to Springfield for an overnight at one of the inns or hotels. Many tourists would take the steamboat to Cooperstown for a few days in the village.

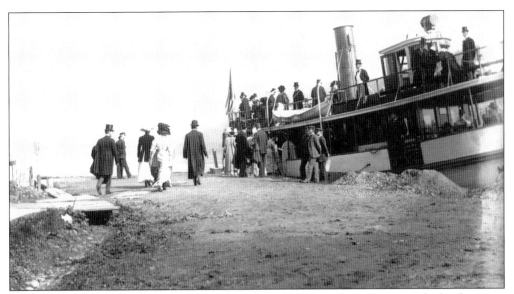

PASSENGERS READY TO BOARD THE STEAMBOAT. In addition to stops at one of the landings, an individual camp or group of camps could put out a white flag indicating the steamboat should stop to pick up passengers or goods. The steamboats also delivered mail and groceries. (Courtesy of the Smith and Telfer Collection, Fenimore Art Museum.)

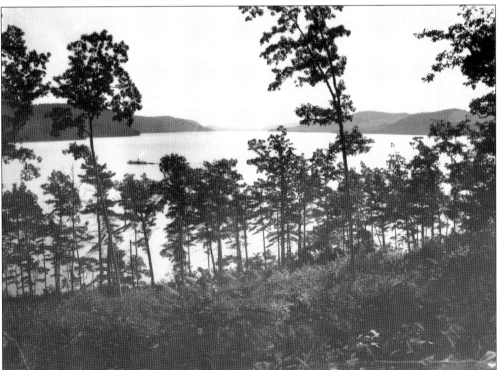

VIEW LOOKING SOUTH TOWARD COOPERSTOWN. The steamboats on Otsego Lake, seen here from Hyde Hall, carried passengers from Steamboat Landing and Springfield Landing to Cooperstown and back. One of the sites from the very popular James Fenimore Cooper novels that could be observed along the way was Hutters Sunken Island. (Courtesy of Fenimore Art Museum.)

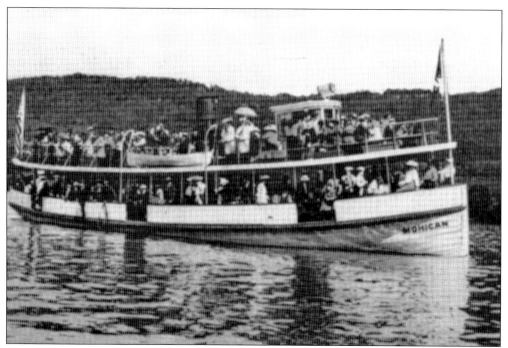

THE MOHICAN STEAMBOAT, 1905. A double-deck steamer, shown loaded with passengers, the *Mohican* was 80 feet long and 19 feet wide. With a capacity of 400 passengers, the steamboat was lighted by electricity and traveled the lake at 12 miles an hour. Steamboat service on the lake ended in 1931.

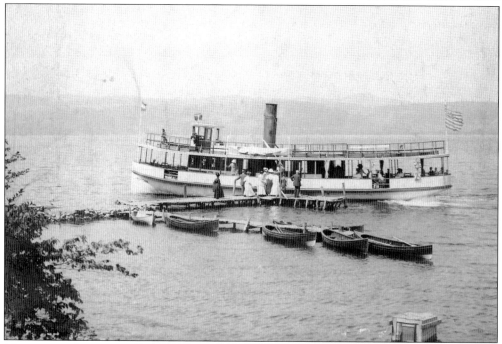

MOHICAN AT DOCK. In addition to the *Mohican*, other steamboats plied the lake, including the *Gem of Otsego*, the *Mabel Coburn*, and the *Cyclone*. The first to be launched was the *Pioneer* in 1858, followed by the *Mary Boden* in 1869 and the *Natty Bumppo* in 1871.

KINGFISHER TOWER, 1876. Built by Edward Clark on the eastern shore of Otsego Lake, the tower is 60 feet tall. It is a Gothic Revival structure designed by Henry Janeway Hardenbergh who also designed other properties for Clark, including the famous Dakota Apartments on Manhattan's Upper West Side.

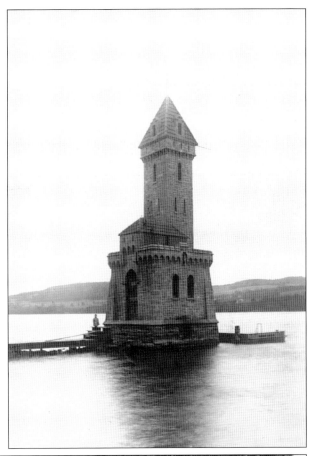

OTESAGA HOTEL, 1909. By 1909, the luxurious Otesaga Hotel was open and became the premier destination for people traveling from Springfield by steamboat to Cooperstown. Situated on the shores of Otsego Lake, the hotel features an expansive porch with views looking north toward the Kingfisher Tower and Springfield's Mount Wellington beyond.

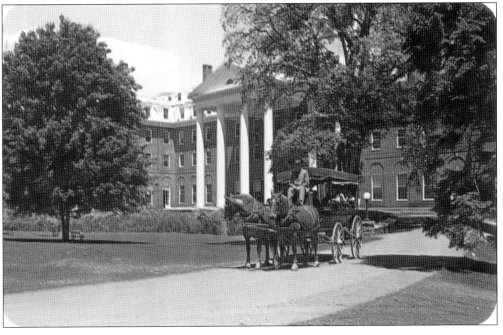

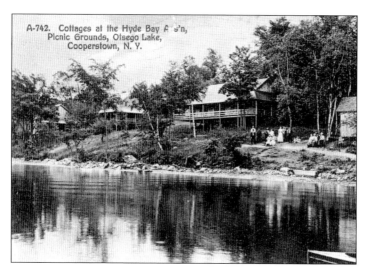

A-742. Cottages at the Hyde Bay A 'n, Picnic Grounds, Otsego Lake, Cooperstown, N. Y.

HYDE BAY COLONY. Hyde Bay was first established in 1902 as a swimming and picnicking place for local families. Rathbun's, as it was known at that time, grew in popularity and began to welcome guests with rustic overnight accommodation and served family-style chicken and fish dinners. Over time, cabins were constructed, a tennis court was installed, and other summer activities were provided.

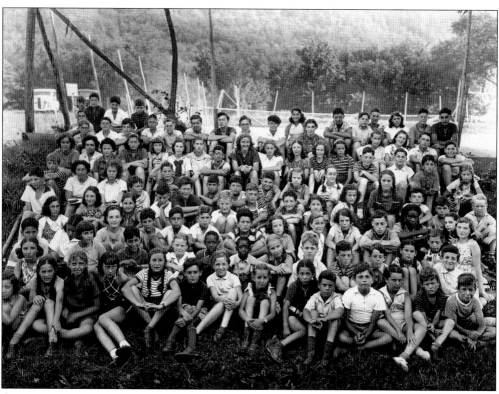

CAMPS ON THE LAKE. There have been and still are many organization camps around the lake including Girl Scout and Boy Scout camps, a Baptist sailing camp, and pictured here, the Ethical Culture Society camp. This picture, taken in 1937, shows the children gathered on the southern shore of Hyde Bay where the camp was located.

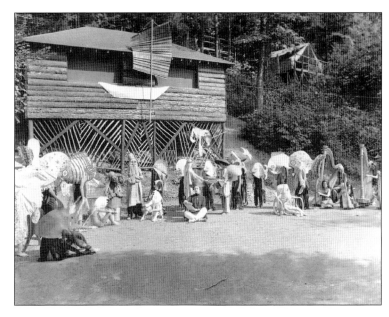

PATHFINDER LODGE. Rustic camping grew in popularity in the 1920s. These camps offered a wide range of activities from swimming and calisthenics to nature study and arts and crafts. Pictured here is a festival where the campers are dressed in fish costumes. The evening campfire was the setting for storytelling and songs. (Courtesy of the Smith and Telfer Collection, Fenimore Art Museum.)

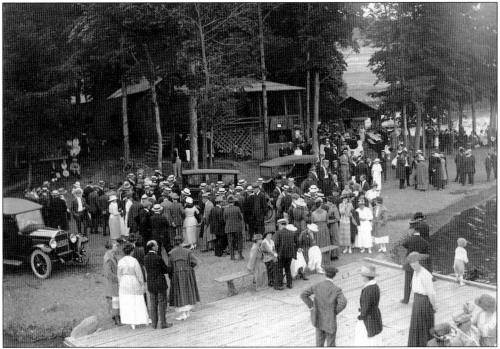

THREE MILE POINT. Three Mile Point, originally owned by the Cooper family, has been a popular picnic and swimming area since the early days of Cooperstown. A large crowd attending the Dairymen's League Picnic is pictured here. In 1871, the property was leased and then purchased in 1899 by the Village of Cooperstown. (Courtesy of the Smith and Telfer Collection, Fenimore Art Museum.)

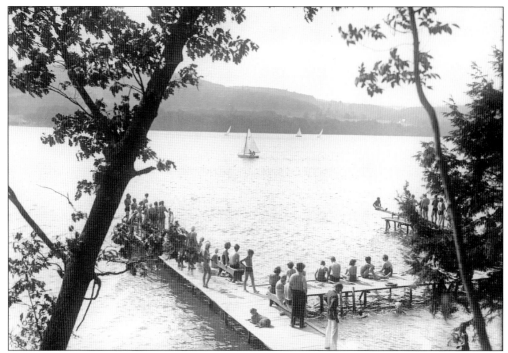

FAIRY SPRINGS, 1937. Located a short distance north of Cooperstown on the eastern shore, Fairy Springs Park allows public access to the lake with a swimming dock and picnic area. The terraced grounds were donated by Robert Sterling Clark in 1937 and are managed by the Village of Cooperstown. (Courtesy of the Smith and Telfer Collection, Fenimore Art Museum.)

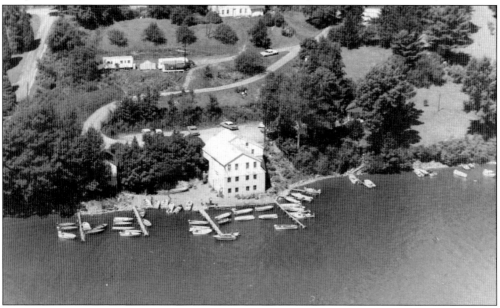

THAYER'S BOAT LIVERY. Boat rentals for fishing or a leisurely day on the water were available all season long at Rufus Thayer's. Rufus was an avid fisherman and would advise clients as to what fish were biting on any day. Oars or a small outboard motor were supplied, and bait was available. Hot dogs and coffee were just up the hill at his mother Martha's road stand.

Eight

FOURTH OF JULY CELEBRATION

The residents of Springfield have always felt a deep connection to the Revolutionary War period and the declaration that established the thirteen colonies as free and independent states. The Clinton–Sullivan Campaign was ordered by George Washington in response to the Iroquois- British attacks. In Springfield, a staging camp for the campaign was set up on Otsego Lake. That history left an indelible mark on future generations, and the parade, held annually with few exceptions, keeps that spirit alive.

Springfield's Fourth of July Parade, first held in 1913, is the second oldest in the nation and is truly a red, white, and blue regional event. The welcoming signs to Springfield proclaim the town as "the place to be on the Fourth of July," and thousands of people fulfill the order year after year. Marching bands and marching organizations come from neighboring towns to participate in the parade. Fire trucks and their volunteers bear the names of many different municipalities. Decorated floats, cars and trucks, horses and wagons, and tractors stream by, usually illustrating the annual theme developed by the Fourth of July Committee. A bandstand, decked in red, white, and blue bunting, is set up for the announcement of the participants. Later, the prizes and awards are presented at the community center following the National Anthem.

Traditional American food has always been a part of the parade day celebrations, including the long-established chicken barbecue with all the sides. In addition, various booths are set up to sell homemade cakes and pies by the slice or whole because this celebration is as American as apple pie. All this sets the perfect scene for a family reunion, and many families have established this day specifically for their annual gathering. Games and sports for kids are planned, and theatrical enactments and entertainment galore are produced.

The Springfield fireworks display, also a regional draw, is held at the Glimmerglass State Park and is made even more spectacular by the reflections in Otsego Lake. The fireworks are preceded by a concert in the park, and all this is made possible at no charge by the Fourth of July Committee. It is a resounding end to a day of long-loved Springfield traditions.

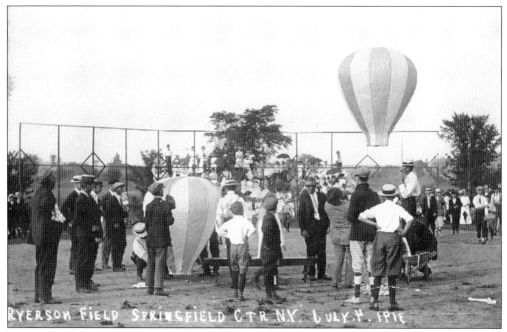

FOURTH OF JULY PARADE, 1913. Revelers gathered at Ryerson Field to watch the hot-air balloons launched just prior to the assembly of the marchers. The grandstand is filled with observers anticipating the day's activities. The ladies in their long dresses carry umbrellas for sun protection. The men wear straw hats, while the boys in knickers wear caps.

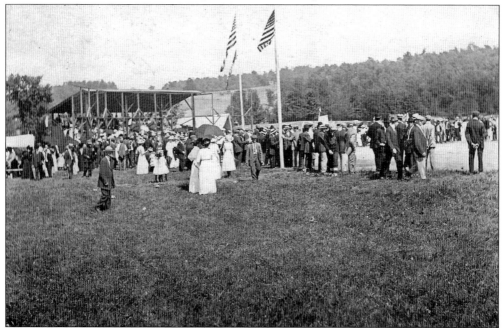

AN EARLY CELEBRATION. The crowds gathered before the parade to listen to speeches and play games. After the parade, prizes were awarded to those who did the best job of showing national pride. Later, the Fourth of July Committee would develop an annual theme and award prizes for the best representation of that theme.

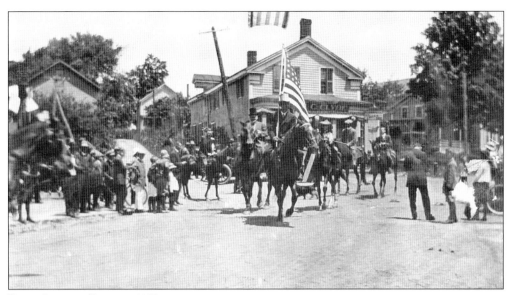

Rider Leading Parade, 1919. Horses led the parade in the early days, with the lead rider carrying the American flag, usually wearing a top hat. People crowded the streets in anticipation of the great American show. Today, horses and their riders are traditionally placed at the end of the parade.

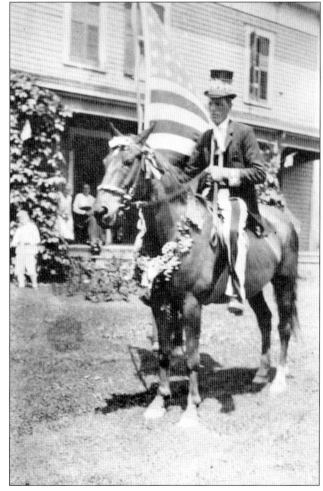

Horse and Rider, 1917. This rider is dressed in striped pants and a top hat, reminiscent of the American icon Uncle Sam, the personification of the United States since 1812. Both the rider and his horse are festooned with fresh flowers to express the importance of the day.

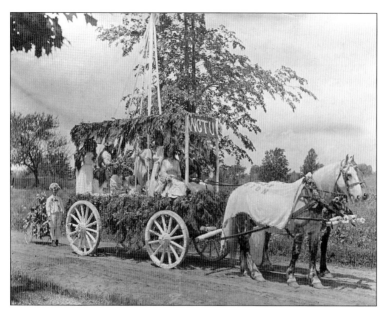

WOMEN'S CHRISTIAN TEMPERANCE UNION (WCTU) FLOAT. The WCTU was among the first organizations of women devoted to social reform. An international group, it advocated for the prohibition of the manufacture and sale of alcoholic beverages, or "demon rum." The group also supported women's suffrage and social issues such as labor, public sanitation, and international peace.

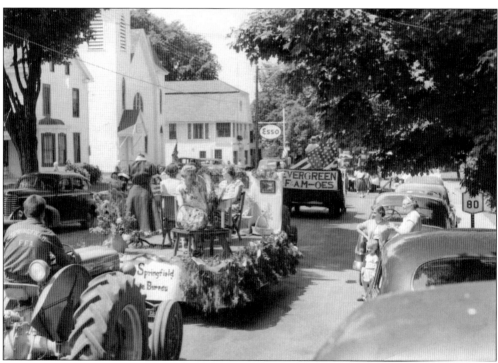

SPRINGFIELD HOME BUREAU. Local members of the bureau gathered regularly to advance their domestic skills and enjoy social interaction. The New York State Federation was founded in Ithaca in 1919 and promoted various topics on home life, including consumer issues, and to the community, including health and safety.

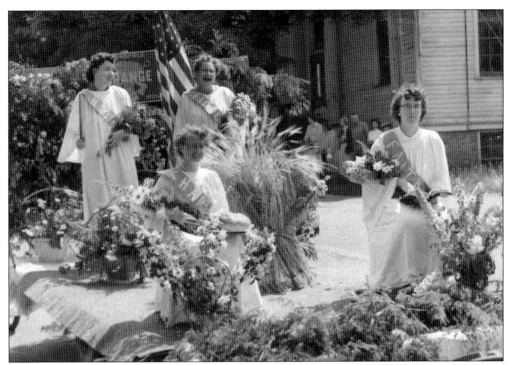

GRANGE FLOAT, 1954. The ladies of the Grange riding on the float represent the Grange ideals of hope, fidelity, charity, and faith. Springfield farm families had a long history of Grange activity and were very active well into the 1980s, promoting the social and economic needs of local farmers.

GRANGE FLOAT, 1959. The Springfield Grange celebrated the admission of Alaska and Hawaii as states in the union with this float. A project like this was a good way to involve the children in Grange activities while teaching them American history. At the time of this parade, 47 years had passed since the last state had been admitted in 1912.

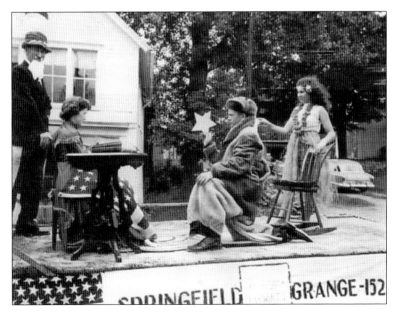

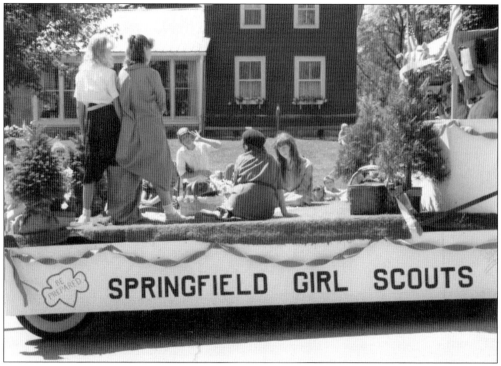

GIRL SCOUTS FLOAT. Along with the scout motto "Be Prepared," the Springfield Girl Scouts' float illustrated, through objects displayed, their interests in camping, hiking, picnicking, and games. The float also included the variety of uniforms the girls would wear as they moved up through the years. The local troops were active through the 1970s and 1980s.

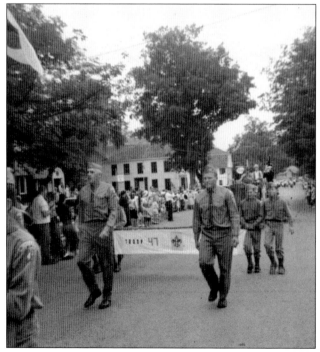

BOY SCOUTS MARCHING. In 1965, leaders Ed Walton and Harold Murcray lead the boy scouts of Troop 47 in the parade down Main Street. The organization remained active under other leadership until 2019. Troop meetings, Camporees, and summer camps were popular activities for the boys.

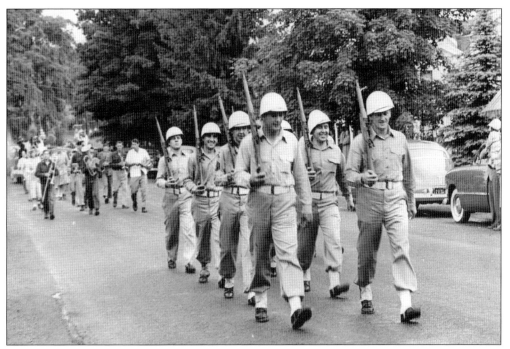

Veterans Marching, 1950. Members of the McShane-Buddle American Legion Post were proud to show their excellent marching skills. Post 1503 was named after two Springfield veterans who lost their lives in World War II. The World War II veterans marching here represented the dozens of men and women who served their country in different ways.

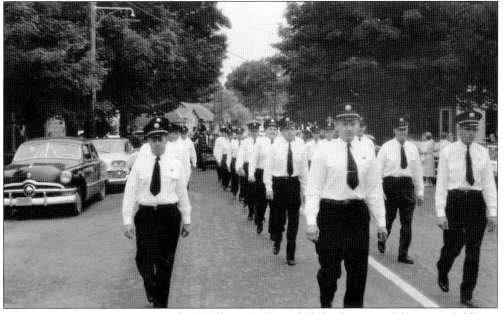

Springfield Fire Department. Chief William Gerhartz led the firemen of the Springfield Fire Department down the road in Springfield Center. There are two companies today: Company No. 1, located in East Springfield, and Company No. 2, in Springfield Center. When the alarm sounded, both companies responded and today there is no separation of companies.

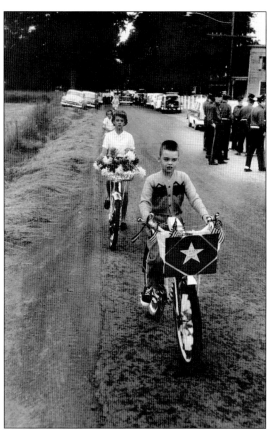

DECORATED BIKES, 1959. Youngsters also demonstrated their parade spirit by decorating their bicycles and riding them in the parade. In 1959, the parade theme celebrated America's new states, Alaska and Hawaii. Pictured here are Karen Weaver and Jim Rogers representing the theme for that year.

LOCAL FUN, 2005. The Fourth of July spirit in the community is regularly demonstrated among locals by individual participation in the parade. This fellow is pulling the old carriage through town because, as the sign says, "I Lost My Horse in a Poker Game." Such creative fun still brings smiles to the faces of those in the audience.

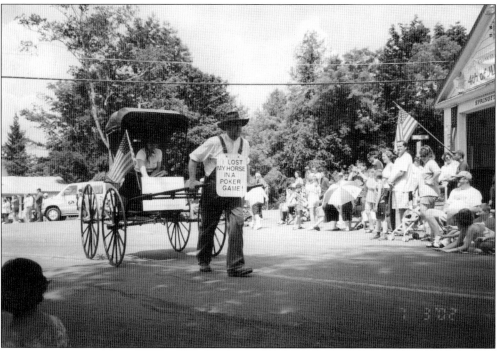

BOY-POWERED FLOAT. People young and old were encouraged to show their parade spirit, and Jeremy Harvey, pictured here, was more than willing to participate in the Springfield story. This little "farm boy" towing his cart shows what may become of local farm animals. The sign reads. "This Little Piggy Went to Market."

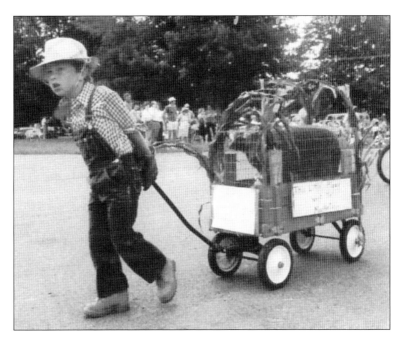

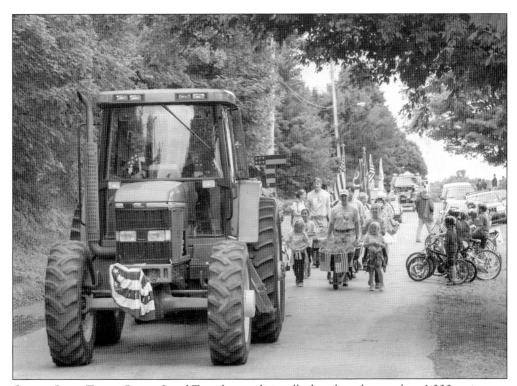

OTSEGO LAND TRUST. Otsego Land Trust has traditionally distributed more than 1,000 native tree seedlings each year at the Springfield Fourth of July Parade. White pine, spruce, larch, and other seedlings have been planted by families throughout Springfield and many have grown to impressive sizes over more than a decade.

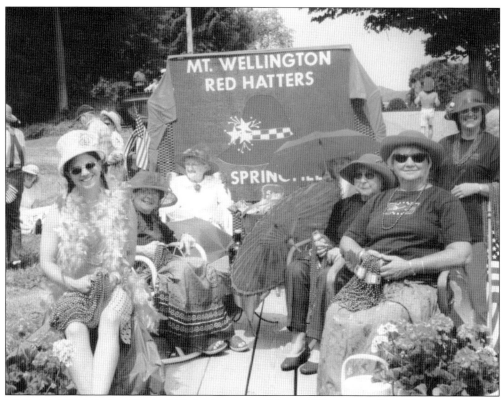

MOUNT WELLINGTON RED HATTERS, 2005. Founded in 2004, this group of friends met for social events and outings and participated in the parade, winning prizes for their efforts. Riding the float from left to right are Emily Dorn, Shirley King, Barb "Wink" Rutler, Janice Maine, Mae Robertson, Jeanette Dorn, and Suzanne Goodrich. The Red Hatters group won the third prize the year this picture was taken.

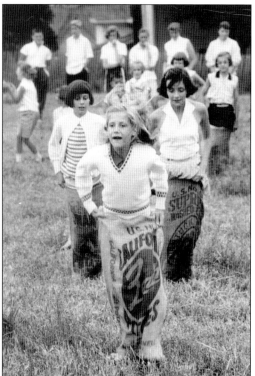

CHILDREN'S GAMES. After the parade and barbecue, many children's games were planned. Often, these were traditional, old-fashioned games typically played at county fairs and picnics at that time. These children are competing in a sack race. Another favorite game was the egg on the spoon race. The adults were usually engaged in softball games.

CHICKEN BARBECUE, 1958. A staple in the Fourth of July celebrations has been the chicken barbecue served up after the parade. In recent years, over 1,300 chicken halves have been consumed on that day. Everett Stiles cooks the chicken, Stub McCarty sits in the truck, and Clarence Burst looks on. The Masons did the cooking in those days.

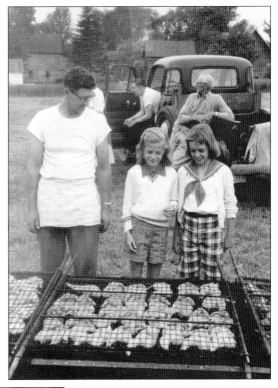

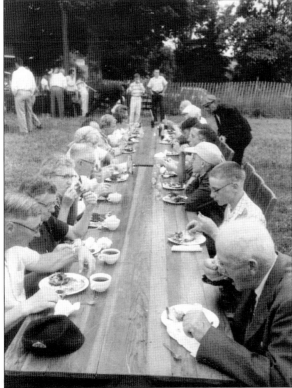

TIME TO EAT. Wooden cafeteria tables were brought out of the school to accommodate the many hungry parade-watchers who bought chicken dinners. Families would congregate to enjoy the feast. The profits from the barbecue went to support the Fourth of July Committee, whose hard work has made the parade and celebrations what they have become.

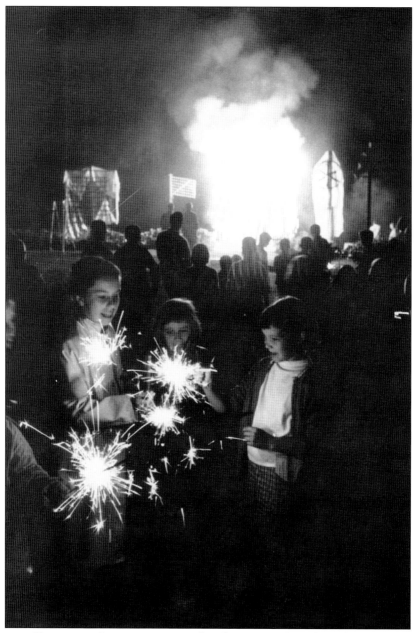

BONFIRE AND FIREWORKS. In previous years, bonfires were often the culminating activity of Springfield's Independence Day celebrations. Following the parade, the prizes, the barbecue, and the games, the bonfire would be lit close to sundown. The children were given sparklers to light and wave through the summer's eve, bringing a festive end to a long day. In more recent years, fireworks displays became popular and are now the traditional end to the day of celebrations. Private companies have been hired to set up the fireworks display at Glimmerglass State Park, and the location on Otsego Lake provides a perfect background. The fireworks reflect off the lake's surface while the sounds reverberate down through the valley. Before the fireworks event, there is a concert staged at the state park for all to enjoy. The park allows for multitudes to gather comfortably while, at the same time, boaters gather in Hyde Bay to listen to the music and watch the display.

Nine

Preserving the Land and Water

Beginning in the mid-20th century, Springfield gained widespread recognition as a place of great natural beauty with historic, recreational, cultural, and agricultural resources. Otsego Lake and the surrounding farms, fields, and forested mountains contain a rich diversity of ecosystems and natural habitats plus an extraordinary view shed. The Glimmerglass Historic District, established in 1999, is 15,000 acres.

Various organizations are working to protect the land and water. The Otsego County Conservation Association, Otsego 2000, the Otsego Lake Association, and the Otsego Land Trust are four examples. SUNY's Biological Field Station has conducted research on the lake and the surrounding area since the mid-1960s. The Thayer Property, situated in Springfield on the western shore of Otsego Lake, stretches up to Rum Hill with a total preserve of more than 500 acres of fields and forests. The Glimmerglass State Park, established in 1963, preserves approximately 600 acres for public use and recreation.

The Glimmerglass Festival is situated on 45 acres of land donated by Tom Goodyear of Cary Mede. Just south of the festival, Mohican Farm sits on the western shore of the lake and is preserved by the Clark Foundation.

In 2001, Amish farmers began settling in Springfield because of its fertile soil and good water. The growth of this community is welcome as they preserve the land and the traditions of agriculture so important to the region.

In her 1850 book *Rural Hours*, Susan Fenimore Cooper recognizes how the "progress of man" may endanger the natural world. She strives to enlighten with poetic descriptions of this land: "These hills, and the valleys at their feet, lay for untold centuries one vast forest. . . . The trees waved over the valleys, they rose upon the swelling knolls." Then she cautions the importance of preservation of the land, warning, "Another half century may find the country bleak and bare, but as yet . . . upon the lake shore, there are several hills still wrapped in wood from the summit to the base." Springfield today celebrates the same pride of place expressed in Cooper's book and endeavors to conserve its beloved land and water.

SPRINGFIELD PUBLIC LANDING BUILDING AND DOCK. The public landing, which opened in about 1930, provides access to Otsego Lake for boating and swimming for Springfield residents. There is a boat launch, docks for rent, and a protected swimming area. A clubhouse has a large room for social activities, a refreshment area, and change-room facilities for bathers. (Courtesy of Maureen and Fred Culbert.)

FARM AT DUTCH CORNERS. This farm, located on the corner of Van Alstine Road and Fassett Road, is currently owned by an Amish family. The previous owners, Gail and John Walrath, wanted to see the land remain as farmland and, although sad to sell the property, were happy to know the farming tradition would be preserved. (Courtesy of Maureen and Fred Culbert.)

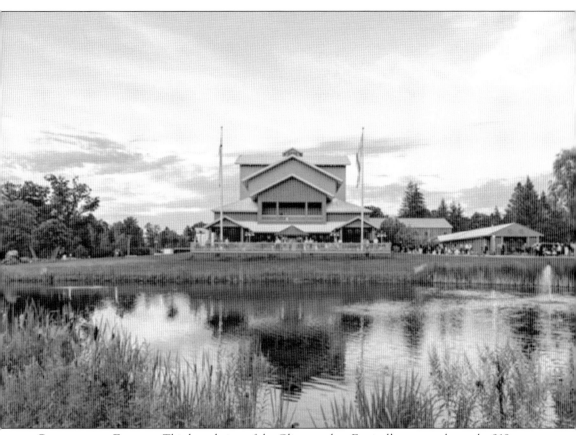

GLIMMERGLASS FESTIVAL. This broad view of the Glimmerglass Festival's campus shows the 918-seat Alice Busch Opera House, designed in 1987 by Hugh Hardy. The architecture is inspired by local barns. The festival grounds are nestled on the northwest shore of Otsego Lake and contain fields and forests where audiences can picnic or stroll. A path winds down to the Goodyear Swamp for views of Mount Wellington. Glimmerglass, an American opera company, is known for producing lesser-known works as well as opera classics and Broadway musicals. Lectures and recitals fill out the season. The Young American Artists Program brings young professionals to study at Glimmerglass, attending classes in acting and diction as well as performing on stage and in solo recitals. Glimmerglass is the second-largest summer opera festival in the United States. (Photograph by Karli Cadel; courtesy of Glimmerglass Festival.)

OTSEGO LAND TRUST, ROSEN PROPERTY. The mission of Otsego Land Trust (OLT) is to conserve the area's natural heritage of woodlands, farmlands, and waters that sustain rural communities, promote public health, support wildlife diversity, and inspire the human spirit. The Rosen property, pictured here, is protected from development through a partnership with Otsego Land Trust signed in 2003. Conservation of the three-acre private parcel with a prime view of Otsego Lake helps to promote healthy soil and clean water. Protecting and watching over land such as the Rosen property helps the ecosystem thrive and helps to keep the water of Otsego Lake clean. Otsego Land Trust is active in the northernmost headwaters of the Susquehanna Watershed. In order to facilitate the preservation of land and water, the OLT "employs a growing number of innovative and flexible land protection tools." (Courtesy of Otsego Land Trust.)

OTSEGO LAND TRUST, FETTERLEY FOREST. Otsego Land Trust acquired the 106-acre Fetterley Forest Conservation Area from Judith and Daniel Fetterley in 2011 to maintain the natural area in perpetuity. The property is open to the public for hiking with the main trail leading through the forest to a ridge overlooking Canadarago Lake. A second trail leads to the vernal pool, a favorite spot for bird-watching. (Courtesy of Otsego Land Trust.)

OTSEGO LAND TRUST, RINGWOOD FARM. The owners of Ringwood Farm have protected the former dairy farm with a conservation easement held by Otsego Land Trust since 2012. The mature forests, prime soils, and important wetlands on these 334 acres build climate resiliency in the region by reducing erosion and supporting diverse habitats. (Courtesy of Otsego Land Trust.)

OTSEGO LAKE ASSOCIATION MEETING. The mission of the Otsego Lake Association (OLA) is to educate, advocate, and participate in the health and well-being of Otsego Lake by facilitating the implementation of the Otsego Lake Watershed Management Plan. It is the only organization focusing exclusively on the lake, made up of 100 percent volunteers. OLA produces publications and hosts open-to-the-public forums. Pictured here is Paul Lord of the SUNY Biological Field Station presenting a lecture on the dive team and lake conditions, one of several presentations at the annual meeting. At the OLA annual gathering, members and guests reconnect and renew memberships, view scientific displays about the health of the lake, immerse in live presentations, purchase OLA apparel, and take home a treasure from the raffle and auction, all benefiting the good works of the Otsego Lake Association. (Courtesy of the Otsego Lake Association.)

OTSEGO LAKE ASSOCIATION
(OLA). OLA proudly supports
the volunteer dive team from the
SUNY Biological Field Station.
This dedicated group works in all
seasons and weather conditions.
They deploy and remove the data
monitoring buoy each year. They
dive to deploy and remove the
"no-wake zone" buoys that protect
the shoreline. They research
in the lake depths and recover
debris and wreckage, all for the
preservation and protection of
Otsego Lake. (Courtesy of the
Otsego Lake Association.)

OTSEGO LAKE ASSOCIATION BOAT PARADE. The Otsego Lake Association's annual decorated boat
parade marked its 10th anniversary in 2022 and has become an Otsego Lake tradition. This is
an all-inclusive event in which everyone can actively participate, whether in a boat on the water
or viewing and cheering from shore. It is a joyful celebration and appreciation of the beautiful
Glimmerglass. (Courtesy of the Otsego Lake Association.)

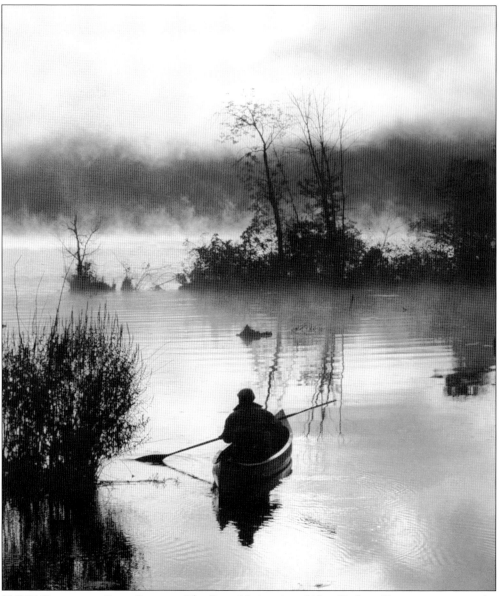

SUNY Biological Field Station. The State University of New York at Oneonta operates the Biological Field Station located in Cooperstown and Springfield, which conducts ongoing research on both aquatic and terrestrial habitats. The long-term research, conducted by undergraduate and graduate students and faculty, is possible because the study sites are in protected areas. The field station states that it is this comprehensive research that allows scientists to distinguish human disruptions of ecosystems from natural fluctuations. The Goodyear Swamp Sanctuary is five acres of wetland marshes adjacent to Otsego Lake and is owned by the SUNY Oneonta Foundation. The swamp is accessible by water and via the Glimmerglass Festival grounds. (Photograph by David Baker; courtesy of Scottie Baker/Natura Productions.)

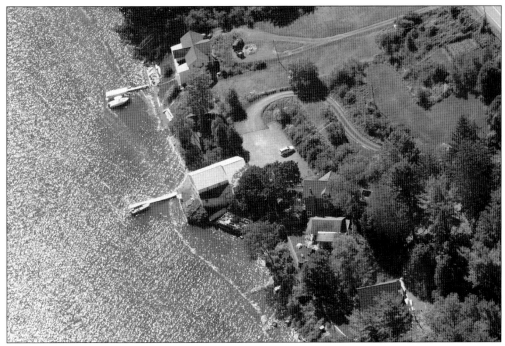

SUNY Biological Field Station, Thayer Farm. The Thayer Farm is owned by the State University of New York College Oneonta Foundation. The property, situated on Otsego Lake, includes fields, forests, and wetlands as well as farm buildings. Since 1967, SUNY Oneonta's Biological Field Station has been a prime environmental testing and training site. The Thayer Properties include 200 acres of lakefront and farmland and 300 forested acres on Rum Hill. Together, they contain four headwater streams flowing into Otsego Lake and a variety of vernal ponds which are valuable ecosystems. 167 acres are protected in perpetuity through a conservation easement held by Otsego Land Trust. (Courtesy of the SUNY Oneonta Foundation.)

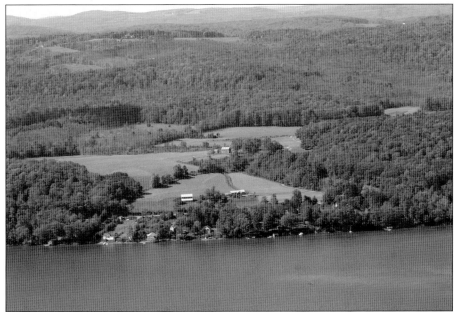

GLIMMERGLASS STATE PARK. Situated on the shores of Otsego Lake, this view of Glimmerglass State Park is looking south from Hyde Hall. The 600-acre park was acquired by the State of New York in 1963 and is preserved for public use and recreation. The park has an expansive sandy beach for swimming, changing facilities, and picnic tables. (Courtesy of Maureen and Fred Culbert.)

GLIMMERGLASS STATE PARK BEAVER POND. The park has a playground near the beach, nature trails with views of the lake, RV and tent camping sites, and a charming beaver pond with a warming shed for winter visitors. Cross-country skiing, snowshoeing, skating, and snow tubing are among the cold-weather activities. (Courtesy of Maureen and Fred Culbert.)

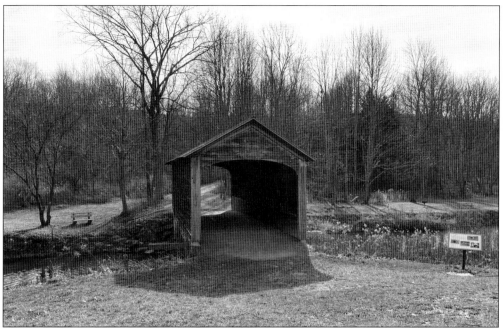

GLIMMERGLASS STATE PARK COVERED BRIDGE. The oldest covered bridge in America is located in the park. Hyde Hall, a National Historic Landmark, has a gatehouse known as Tin Top. In the 19th century, visitors to the mansion passed through Tin Top and then crossed the covered bridge as they entered the vast wooded grounds of the estate.

GLIMMERGLASS STATE PARK PAVILION. The park has three pavilions both open to the air and enclosed against the weather. All are available for family and organization gatherings. The main pavilion, pictured here, is enclosed and located closest to the beach. The beach looks out on Otsego Lake from Hyde Bay. Swimming, fishing, and boating are among the summer activities. (Courtesy of Maureen and Fred Culbert.)

MOHICAN FARM VIEW. Mohican Farm, the former Spaulding estate, is preserved by the Clark Foundation. The property stretches from the shores of Otsego Lake up Allen Lake Road and contains fields and forests and several buildings. This preserved land contains a diversity of flora and fauna and helps protect Otsego Lake. (Courtesy of Maureen and Fred Culbert.)

OTSEGO COUNTY CONSERVATION ASSOCIATION AT MOHICAN FARM. The Otsego County Conservation Association (OCCA) has its offices located at Mohican Farm courtesy of the Clark Foundation. This organization is dedicated to promoting the appreciation and sustainable use of Otsego County's natural resources through research, education, advocacy, planning and resource management, and practice. (Courtesy of Maureen and Fred Culbert.)

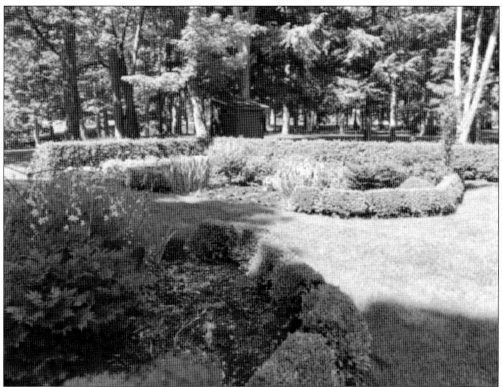

MOHICAN FARM GARDENS. The gardens, originally designed by Ellen Biddle Shipman, are being restored to their former beauty by the Clark Foundation. Born in Philadelphia, Shipman was a noted pioneer in the field of landscape architecture and designed gardens across the United States. From childhood, she had a strong interest in the arts and this was reflected in her lush garden designs. After Ellen married the playwright Louis Shipman, the couple moved to the Cornish Art Colony in New Hampshire, where they were part of a group that included artists Augustus Saint-Gaudens and Willard Metcalf. One of Ellen Shipman's goals in garden design was to provide a place of interaction between the garden and people—a place to commune with the natural surroundings that would provide a sense of peace and privacy. (Above, courtesy of Maureen and Fred Culbert; below, courtesy of Smith and Telfer Collection, Fenimore Art Museum.)

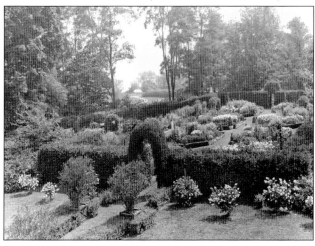

AMISH FARM. This Amish farm on Fassett Road has a house and a barn with two silos. Note the woodpile, the clothes drying on the line, and the traditional Amish buggy, all signs of an alternative lifestyle requiring no power-line electricity or automobiles. The house is heated with wood, and the laundry is hung out to dry in the sun. The scale of the Amish farm is traditionally maintained

to be worked by the family without outside hands. They usually use horses to plow and plant their fields. Amish horse-drawn buggies are a common sight around the town of Springfield. (Courtesy of Maureen and Fred Culbert.)

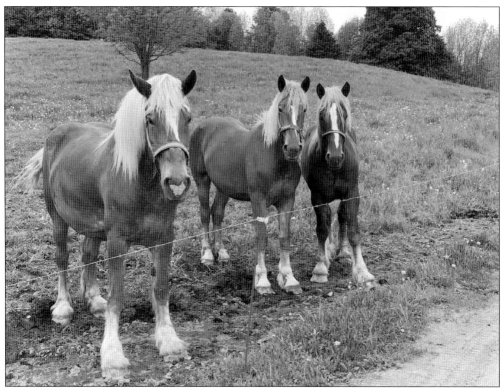

AMISH HORSES. Amish farmers use horses to plow and plant their fields instead of tractors and combines. The Amish values of hard work and simple living are in keeping with farming culture. Fathers stay close to home and work with their sons in tending the land and animals. (Courtesy of Maureen and Fred Culbert.)

AMISH HORSE AND BUGGY PULLING A BOAT. This Amish horse and buggy are set up to tow a row boat to Otsego Lake. The Amish use the public landing in Springfield to launch boats for a pleasant day on the water or maybe a day of fishing. The landing is set up to accommodate the horses and provide parking for the buggy. (Courtesy of Stacey Gibson Calta.)

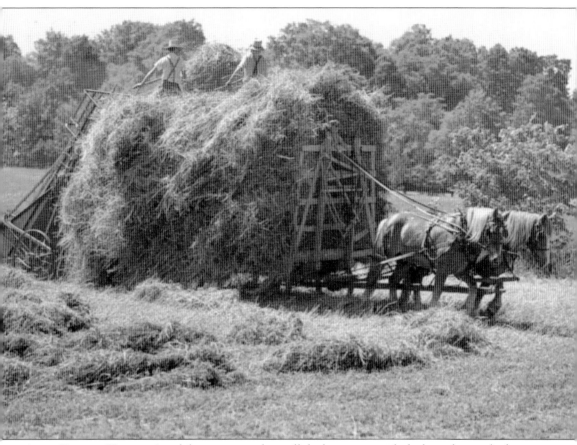

AMISH FARMERS HAYING. Amish horses are used to pull the hay wagon with the hay rake attached at the back. The Amish, for the most part, use no industrial equipment in their farming and gardening practices. The men work together to plant and harvest a variety of crops, usually using manure fertilizer and crop rotation to sustain the soil. The main crops grown by the Amish are wheat, corn, soy, and hay. The men are stacking the hay, which will be transported to the barn and used to feed livestock. The typical Amish farm raises cows, sheep, and horses. The Amish of Springfield also grow vegetables and fruit to be sold at farmers' markets and roadside stands around town. Amish greenhouses, operated by the women, provide flowers and plants to the region's residents and are another source of income for Amish families.

DISCOVER THOUSANDS OF LOCAL HISTORY BOOKS FEATURING MILLIONS OF VINTAGE IMAGES

Arcadia Publishing, the leading local history publisher in the United States, is committed to making history accessible and meaningful through publishing books that celebrate and preserve the heritage of America's people and places.

Find more books like this at
www.arcadiapublishing.com

Search for your hometown history, your old stomping grounds, and even your favorite sports team.